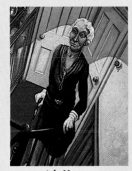

Frederick Arthur Green
(1868–1934) = *Ada Varney*
(1872–1953)

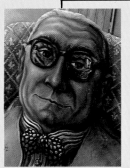

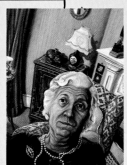

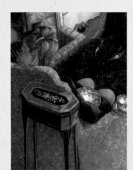

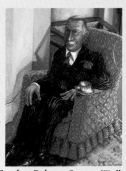

Frederick Sandall Green
(1899–1961)

Winifred
(1896–) = *Cyril Griffin*
(1892–1957)

Edith Margaret
Howis Croxford
(1911–) = *Gordon Roberts Cozens-Walker*
(1900–1981)

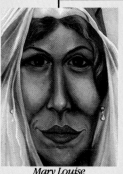

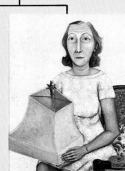

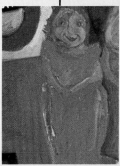

Mary Louise
(1938–)

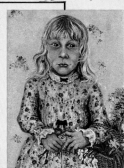

Lucy Rebecca
(1970–)

Raymond
(1921–)

Pamela
(1926–)

Victoria Margaret
(1945–)

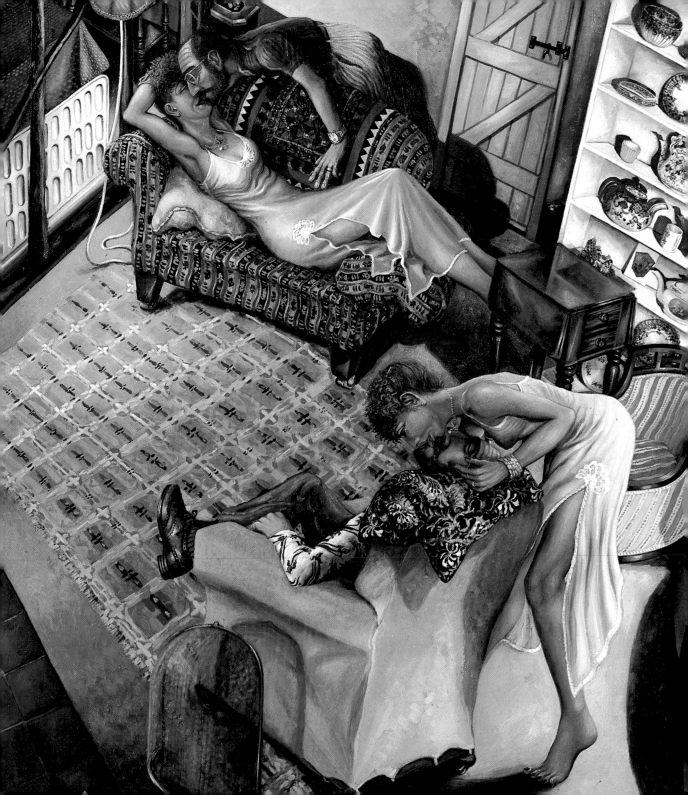

a green part of the world

Paintings by Anthony Green

Edited by Martin Bailey

Por Jean and Tony
with my love.
Anthony Green. '87.

THAMES AND HUDSON

For Mary

© 1984 Thames and Hudson Ltd London
Illustrations © Anthony Green 1984

Printed and bound in Italy by Amilcare Pizzi Arti Grafiche, Milan

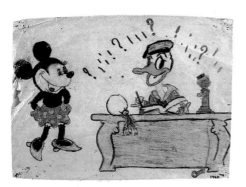

Minnie Mouse and Donald Duck

Frontispiece: The Loving Room
Mole End, Church Lane,
Little Eversden, CB3 7HE

I am a private person. But as an artist, I have chosen to display my work in public. My aim is to reach both the art expert and the layman. Chronicling and exhibiting my personal life for over twenty years has exorcised some of my demons. There are only a few secrets left in the confessional now.

As a young child one of my favourite activities was painting and drawing. I was born in 1939. My first artistic memory, at the age of seven, is of copying Mickey Mouse. Later I went to Highgate School where Kyffin Williams R.A. introduced me to Van Gogh and oil painting. During my summer holidays in Paris I discovered the Louvre. There Delacroix, Courbet, David and Géricault amazed and delighted me with their huge scale, exciting subject matter and breath-taking skill. I wanted to be a professional artist.

Just before my seventeenth birthday I entered the Slade School of Art, and there I was taught to see. My drawing developed and I also learned about perspective and anatomy. I copied sunflowers in the National Gallery, pastiched Soutine, and was entranced by the narrative clarity of the early Flemish painters.

I painted about three hundred pictures as a student. Many of them were bad, and over the years I have destroyed most of them. But this prolific period was important: I taught myself how not to paint. Like the juggler or acrobat, the artist only improves with the constant and unremitting practice of his craft.

7

Copy of Van Gogh's Sunflowers

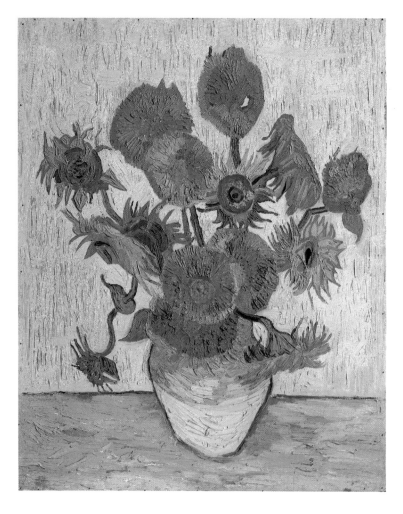

La Mariée

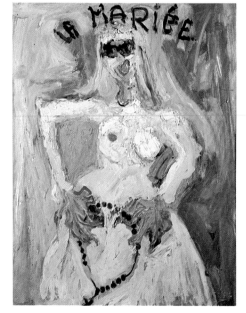

Towards the end of my student days I became increasingly dissatisfied with my subject matter and my reasons for painting. Centuries ago I would have had to work for a king or a pope. Now neither needed me. I could play with art – and be almost irrelevant.

When I left the Slade in 1960 I won a French government scholarship and lived in Paris for a year. Then whilst staying with my uncle and aunt in Châteauroux I found my way. As an eighteen-year-old student, I had fallen passionately in love with a beautiful girl. This was my crucial

8

breakthrough as an artist. Falling in love gave me the motivation and subject matter I needed – I would chronicle my relationship with Mary, our family and its continuing story.

The intensity of our love, my father's recent death and my mother's happy second marriage dominated my world in the way that war and faith or sacred and profane love had inspired others. As our children grew up, each year brought new joys and experiences, sometimes sadness. I have tried to chronicle our middle class family life and my love for Mary – with its contentment and insecurity. Occasionally, I hope, the spectator will be jolted.

Our family has had its share of pleasure and pain. The tensions are never forgotten, but difficult to fix in paint. My pictures do not judge; they simply mirror events. Inevitably my family's frailties can only be hinted at. I don't want to hurt my family, they are who I am.

I passionately believe in figurative art and totally reject suggestions that it has lost its relevance. Since man first scratched magic images on cave walls thirty-five thousand years ago, he has looked at himself in his mirror: gazing upon his fears, aspirations and possessions. Too often the contemporary artist uses a clouded mirror.

I want to illuminate our world, and even stretch the preconceptions of those who look at my pictures. My concerns are universal, sometimes tasteless, frequently artless, but never dulling. I wanted to paint adolescence, bicycles, carpets, dog, Eric, failure, Greens, hair, irritation, Joscelyne, kisses, Mary, nasturtiums, optimism, penises, quiet, roses, sexuality, tenderness, undies, vice, walls, x-shapes, Yvonne and much much more.

The pictures in my mind have no edges. I soon realised that my developing images did not have to be contained within the traditional rectangle. My first shaped painting was made in 1964 influenced, I now recognise, by early

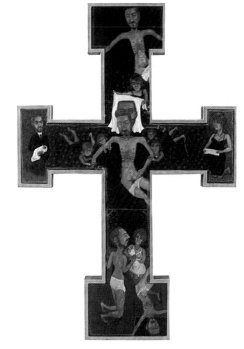

Black Crucifix

Italian art and French Romanesque tympanums. Ideally I would like to paint a picture with an irrelevant perimeter. All the time I am getting closer, but I suspect it's an unattainable goal.

Inside my head I have memory pictures. I do not remember people, rooms, tents, incidents from a fixed viewpoint – I just remember. I remember the personality of objects. Radiators are hard and shiny, my wife's lips are red and soft, my mother's hair is up and French and never down. I remember my father – bit, fat, spectacled, pink and naked, dressed and eccentric, seated, standing, talking, suffering fools not at all, in bed with my mother, alone, sad, and buried.

I remember in precise detail how objects were arranged, people's moods, family tensions and incidents that happened today, last week and up to forty years ago. I have an endless memory loop within my head. My task as an artist is to pluck out these visual images and use them as building blocks for my paintings. Many people claim they cannot remember. But forgotten facts, if searched for hard enough, will be found.

I also want the future. Our two daughters are growing up; their lives will change me. Katie is an art student and might become an artist. Her younger sister, Lucy, is still at school. I want to chronicle their lives.

I usually work 'civil service' hours and the occasional spell in the evening. I work regularly and cannot afford the luxury of waiting for inspiration. I have to trap it as it flies by.

It takes me between one and two months to paint each picture. Only occasionally am I satisfied with a finished work. My imagination is so filled with visions that the physical labour of making them tangible is only partially resolved. I am a compulsive painter.

No 2 Brunswick Mews 1939

My first 'self-portrait'. My mother, two months pregnant, lies on the rug, observed by my father. As a nosey little boy, I would wander around my grandmother's living room, fascinated by all the beautiful objects. I can still picture the place in precise detail.

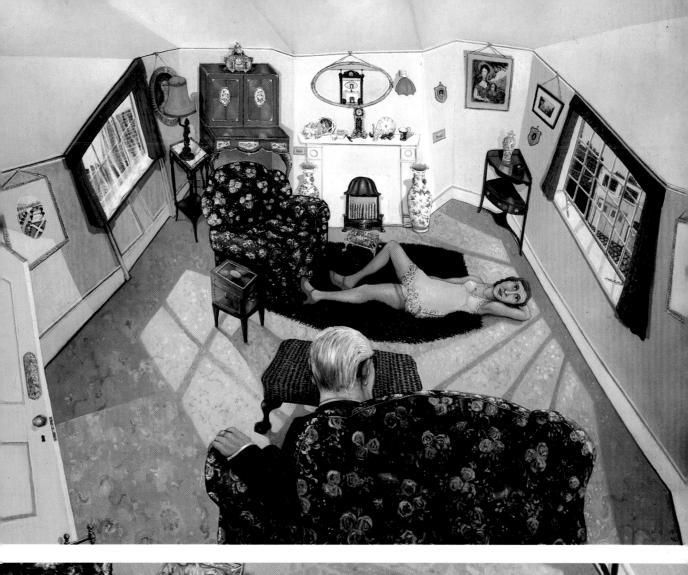
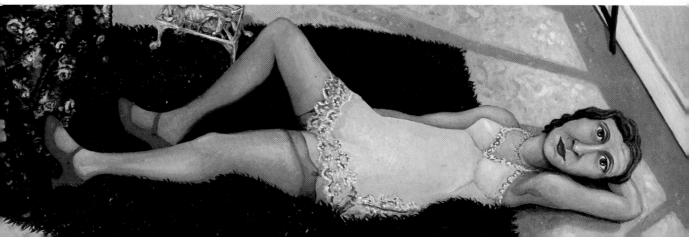

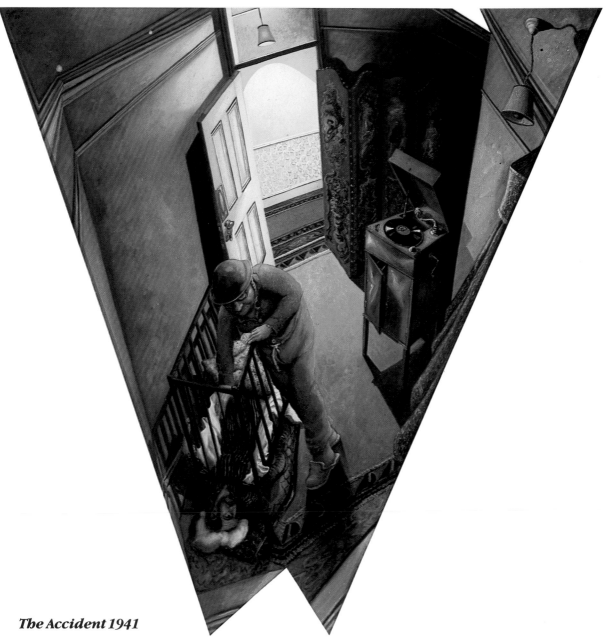

The Accident 1941

I don't remember falling through my cot, but I do recall being rescued by my father. It was my first memory. Our family has always lived in an Edwardian block of flats near Kentish Town in north London. My parents moved into 17 Lissenden Mansions NW5 in 1936 and we are still there. From 1937 to 1952 French grandparents lived two floors below at no. 14.

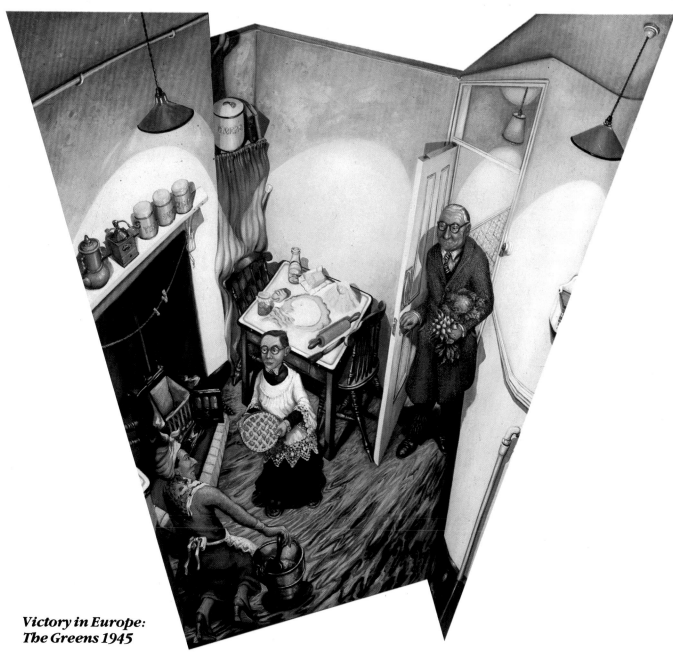

Victory in Europe: The Greens 1945

One of the marvellous liberties of an artist is the ability to squeeze or stretch time, recording a number of events in the same picture. I am showing off my prowess as a pastry cook. Another afternoon, when I was five, my mother Madeleine scolded me because I had come home early and skipped benediction. My red-faced father Eric is bringing home a peace offering after his usual Saturday lunchtime session in the pub. They were divorced in 1953.

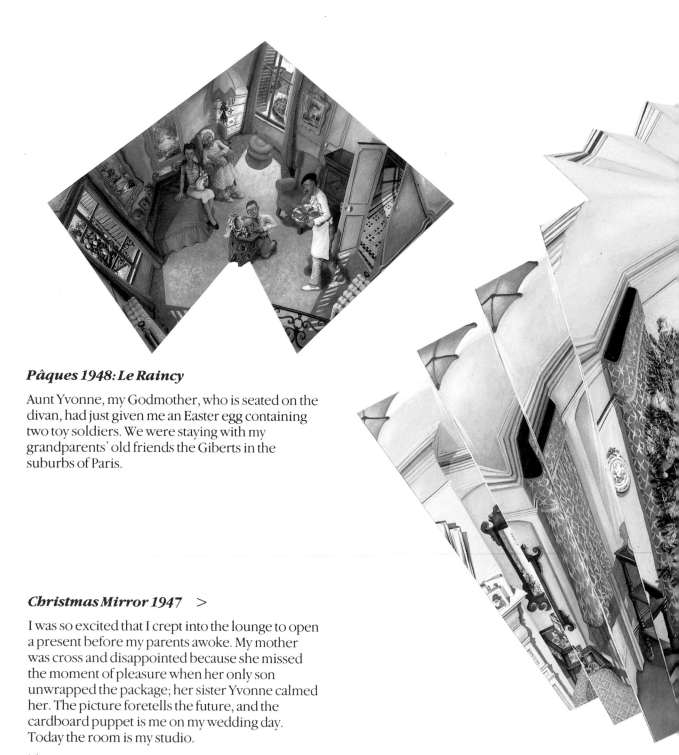

Pâques 1948: Le Raincy

Aunt Yvonne, my Godmother, who is seated on the divan, had just given me an Easter egg containing two toy soldiers. We were staying with my grandparents' old friends the Giberts in the suburbs of Paris.

Christmas Mirror 1947 >

I was so excited that I crept into the lounge to open a present before my parents awoke. My mother was cross and disappointed because she missed the moment of pleasure when her only son unwrapped the package; her sister Yvonne calmed her. The picture foretells the future, and the cardboard puppet is me on my wedding day. Today the room is my studio.

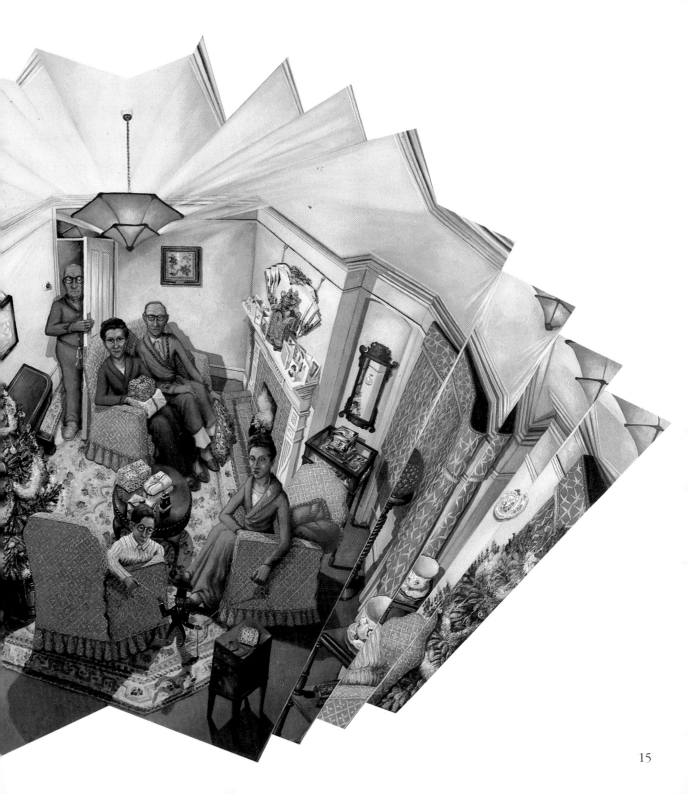

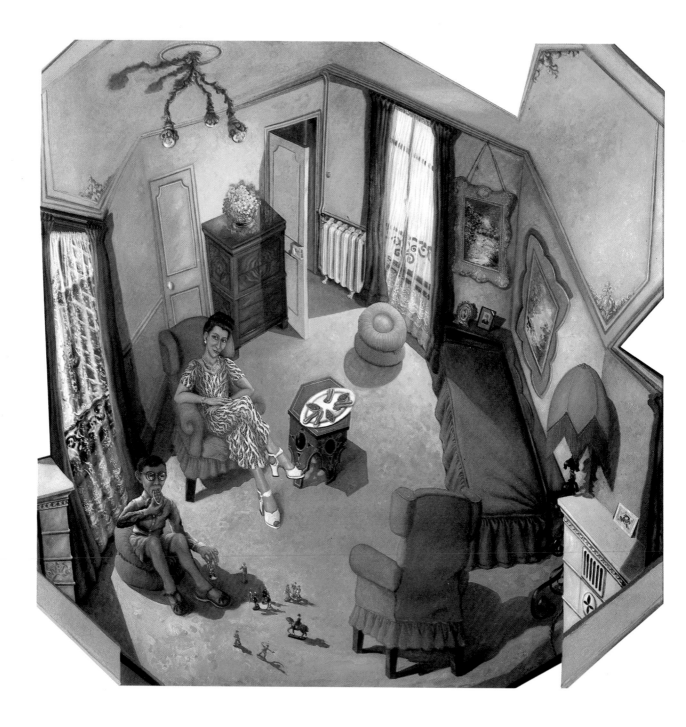

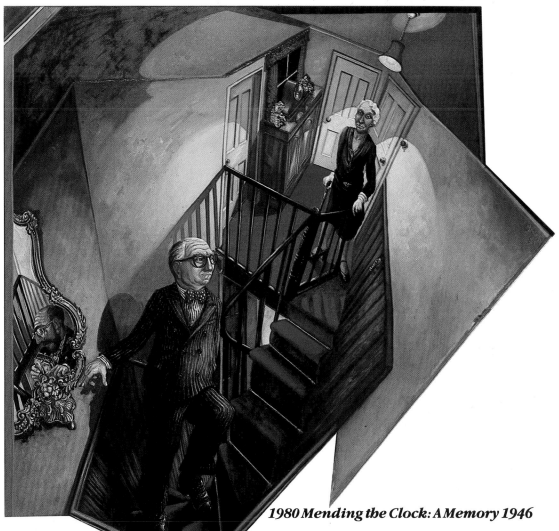

1980 Mending the Clock: A Memory 1946

My grandmother Ada Green greeting her son on one of his Saturday afternoon visits. I appear in the mirror, with the same bow-tie and ring that my father wore. Five years ago, just before I painted this picture, I had moved the clock during my 'annual' attempt to mend it, leaving it in the fireplace between two Chinese kylins. To my amazement I had recreated an arrangement that had existed nearly thirty years earlier when my grandmother lived in Brunswick Mews W1. The chance juxtaposition of the clock with the kylins opened the recesses of my memory.

< ***Madame Madeleine Green et son Fils: Le Raincy, Seine-et-Oise 1948***

Later in the same day when I was given the Easter egg: some of René Giberts' pastries are gone, Madame 'René' has arranged her nasturtiums. My loving Mum looks on while I play with my soldiers – Général de Gaulle takes the salute.

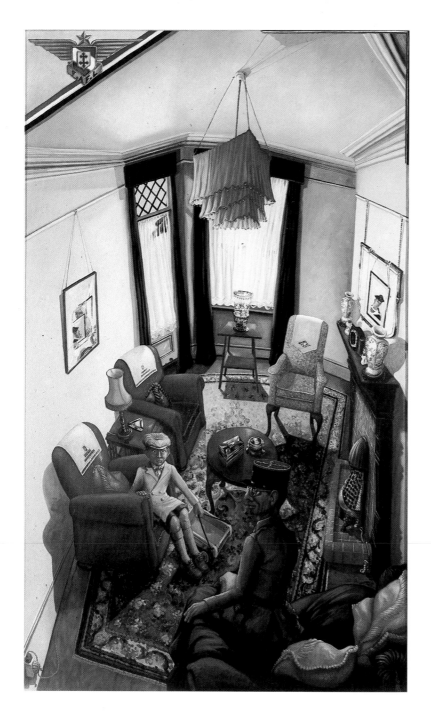

'La France' au 14 Lissenden Mansions 1944?–45

Uncle Maurice's brother, Yvonne's brother-in-law, visited London and slept on the divan bed in my French grandparents' lounge. I am playing with the wooden trolley made by the lover of my English grandmother's lodger.

Casimir Dupont >

My French grandfather was a self-made man, one of three peasant brothers from Pont St Mamet in the Dordogne. In the central panel Casimir (Pépé) and his wife Jeanne (Nana) are listening to news of the Fall of France in June 1940. The top right section shows my grandfather in his chef's hat. I remember playing with it – the hat fell over my ears. In the bottom left: Casimir, having retired as Chef at the Waldorf Hotel, then took over a fish business in Billingsgate. His daughters Yvonne and Madeleine worked for him at various times. The top left shows Casimir arguing furiously about politics with his brother Albert in Berjerac. In the bottom right: my grandfather, after fifty years in London, retired to Châteauroux. He is holding the medal the French Government awarded him for services to the culinary arts. Thanks to Casimir, I knew about good food from an early age.

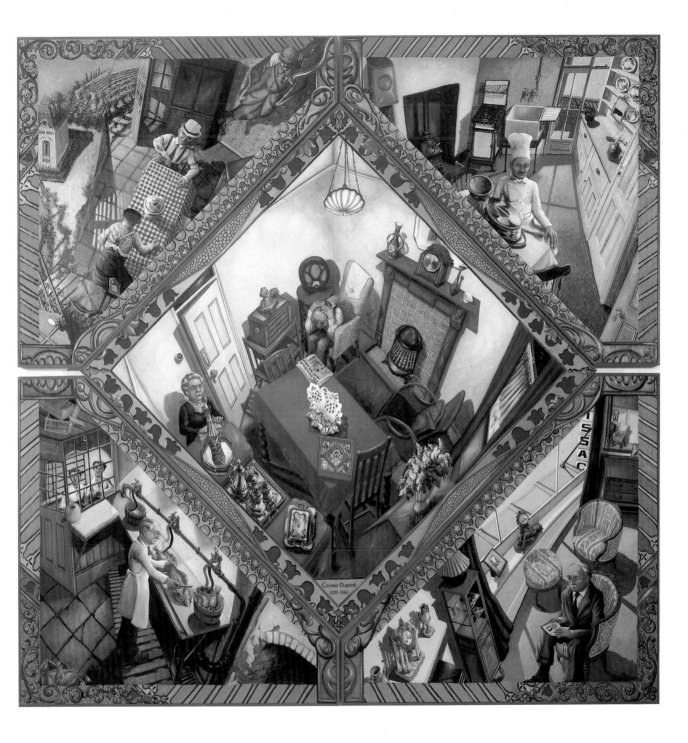

Casimir Dupont
1880-1941

19

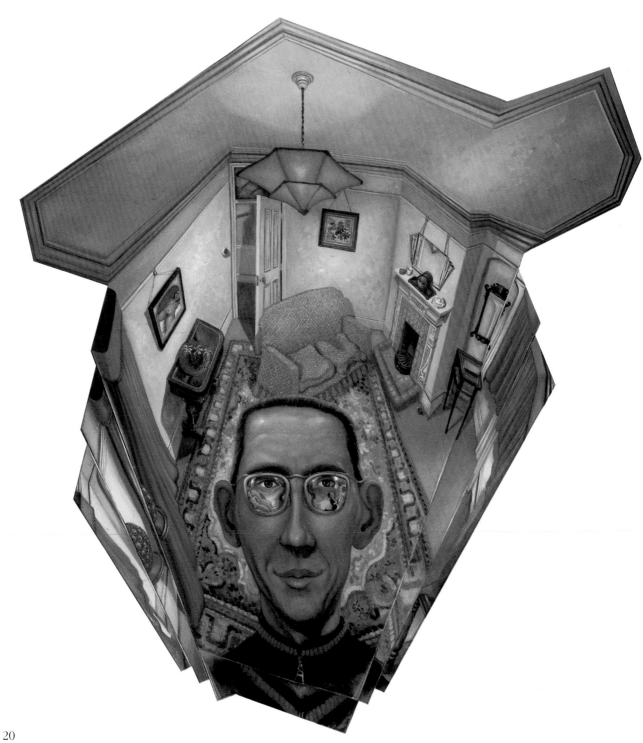

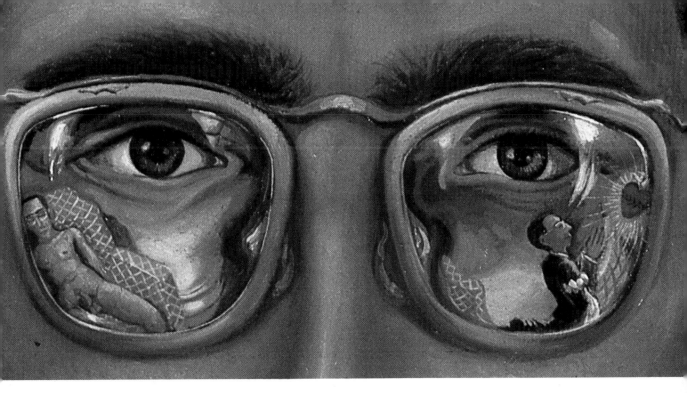

The Mirror 1952–57

The transition from schoolboy to art student. The reflection in the left lens shows a developing concern with my body; the right lens reflects my Catholic faith.

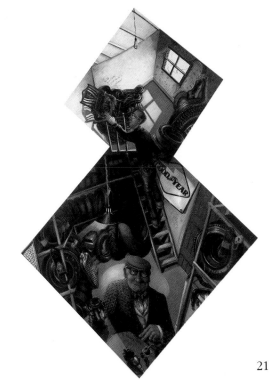

Regal Rubber Company 1954

The tyre business my father ran from dank premises in Lanark Rd W9. One day I climbed into the attic and found a mountain of rickshaw tyres which he had bought at a government surplus auction. On top was a broken antique chair that had belonged to his mother. The chair survived; I mended it, my girlfriend Mary used it at the Slade, and it now lives with us.

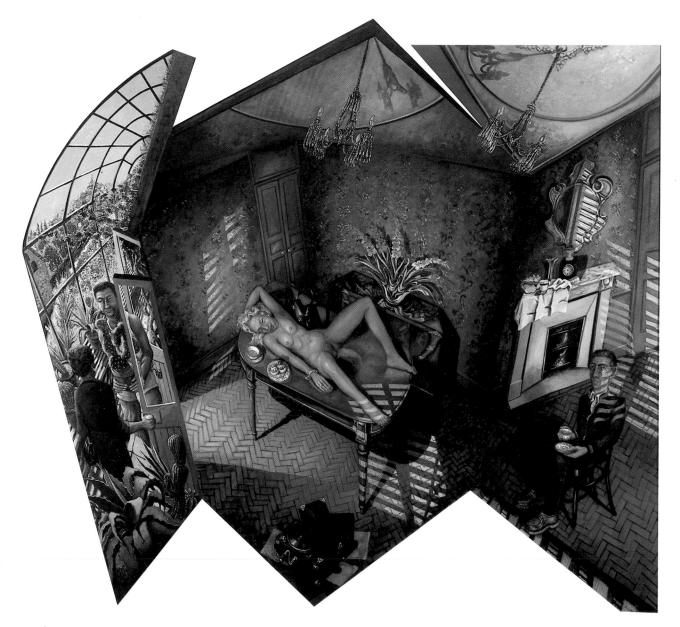

L'Heure de Thé: Argenton sur Creuse, Département de l'Indre

During my French holidays in Argenton, Aunt Yvonne often took me to visit a particularly glamorous friend of hers. Occasionally I was invited by myself. We played records, drank tea, chatted, and ate pastries – I particularly enjoyed *les religieuses*. These social occasions were entirely proper, but my adolescent imagination was not. In the conservatory, my aunt and her friend's husband, apparently unconcerned, are discussing an especially prickly cactus.

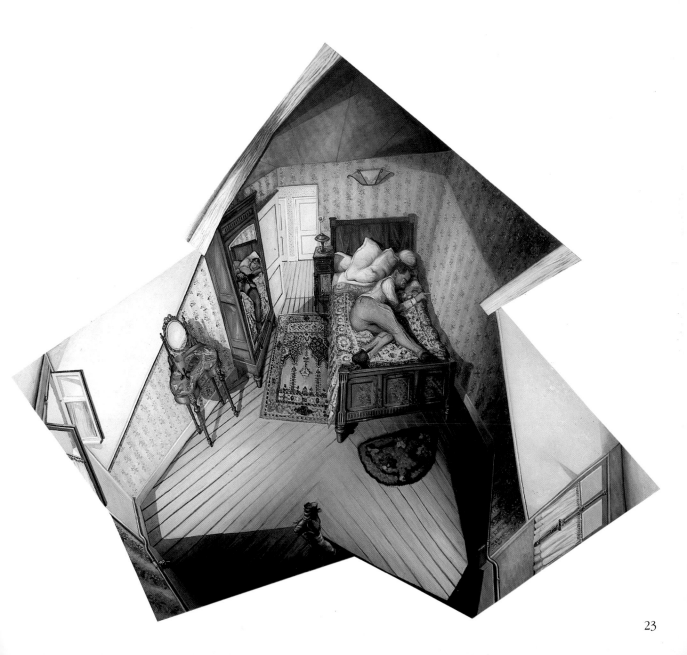

Châteauroux: Les Secrets du Confessional 1957

Daydreaming in the spare bedroom at 17 Rue Victor Hugo during the long summer afternoons.

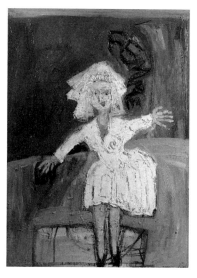

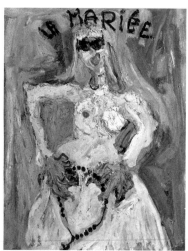

Femme and *La Mariée*

The first narrative works inspired by the expectancy of my forthcoming marriage, painted at Châteauroux in 1961.

La Chambre Bleu >

My French aunt and uncle receiving a letter thanking them for their encouragement during my stay from autumn 1960 to spring 1961. It was then that I had made the crucial artistic breakthrough, the decision to chronicle my love for Mary.

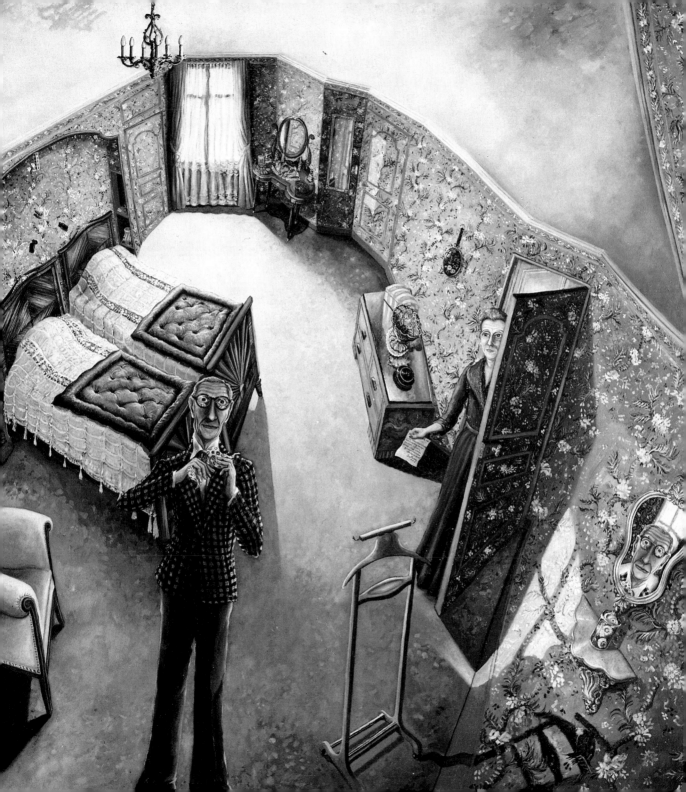

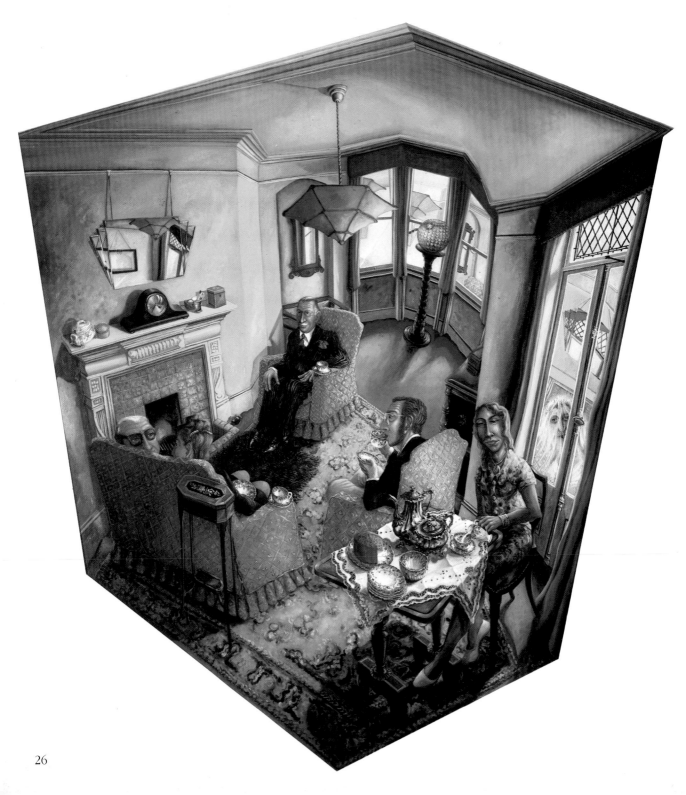

Hall of Mirrors 1958

After the divorce, it was almost impossible to speak my mother's name in my father's presence. The failure of their marriage did not discourage me. Just before our engagement the best silver tea service was got out to entertain Mary's parents in Lissenden Mansions. My father is chatting with Margaret on the sofa. The image of my mother on her first wedding day appears in the French windows; by this time she had remarried. I was on my best behaviour – but terrified that Bob and Margaret might inadvertently mention my mother in conversation.

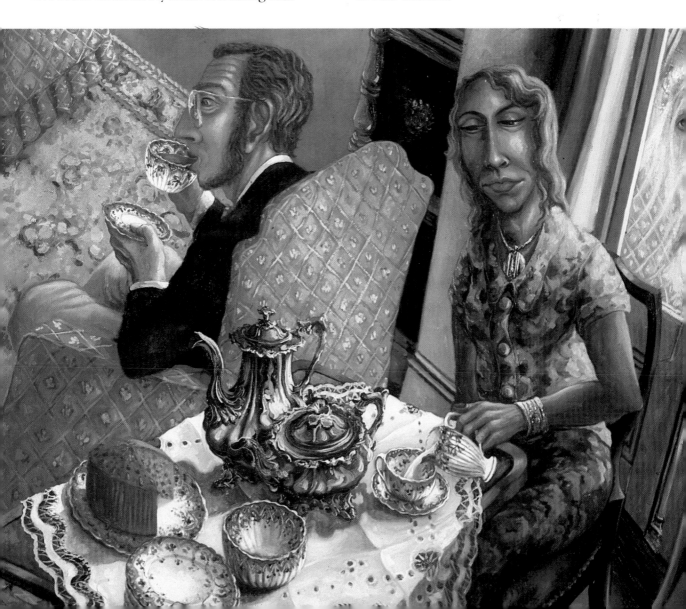

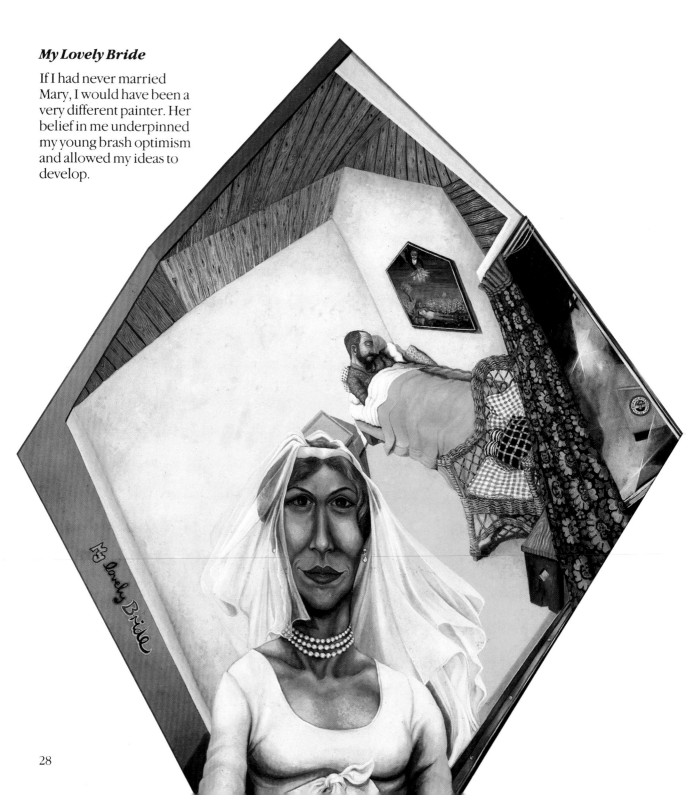

My Lovely Bride

If I had never married Mary, I would have been a very different painter. Her belief in me underpinned my young brash optimism and allowed my ideas to develop.

28

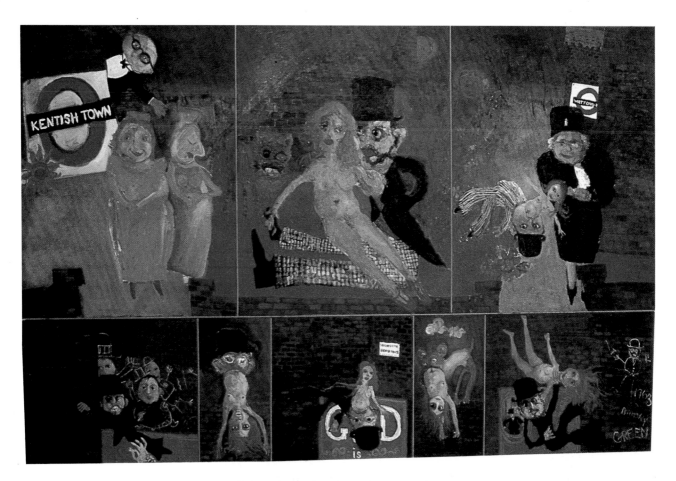

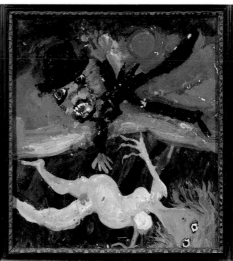

The Wedding

Marriage at Watford
Congregational Church,
29 July 1961. By then
Nonconformism
sustained my Christian
faith.

The Ravisher

I painted this small
gouache on a Wednesday
afternoon while teaching
a still-life class at Highgate
School.

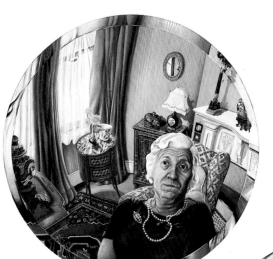

My late Father's Sister: Win

Aunt Win in her London home, surrounded by her possessions which I've admired since I was a little boy.

The Enigma

My father died a few months before our wedding. His ex-wife is reflected in the horn-rimmed spectacles. He was an intelligent man, often witty and occasionally cruel. I miss him.

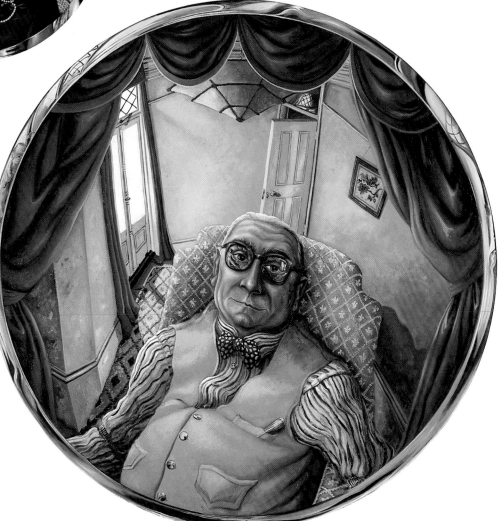

Young Man with a Grenadier

After Eric's death, I was the only Mr Green. Mary and I began our life together in the Lissenden Mansions flat. The lounge became the workroom and the dining room our bedroom. Early in 1962 Alex Gregory-Hood came to the flat to see my new paintings, liked them, and offered me an exhibition at the newly opened Rowan Gallery. I was very excited.

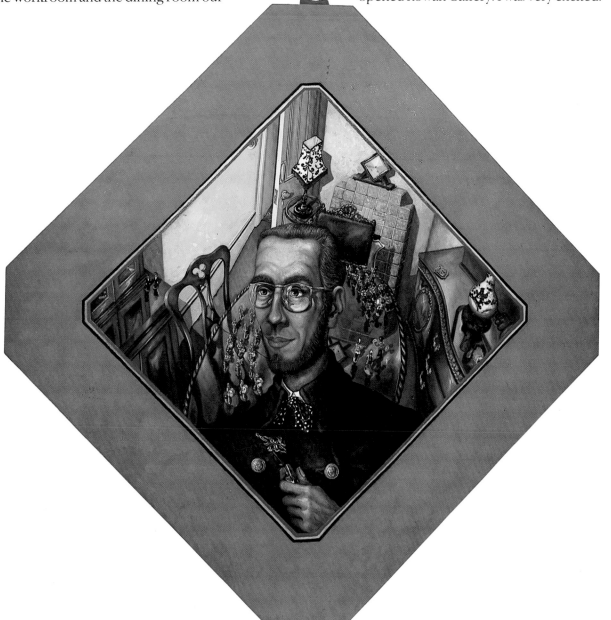

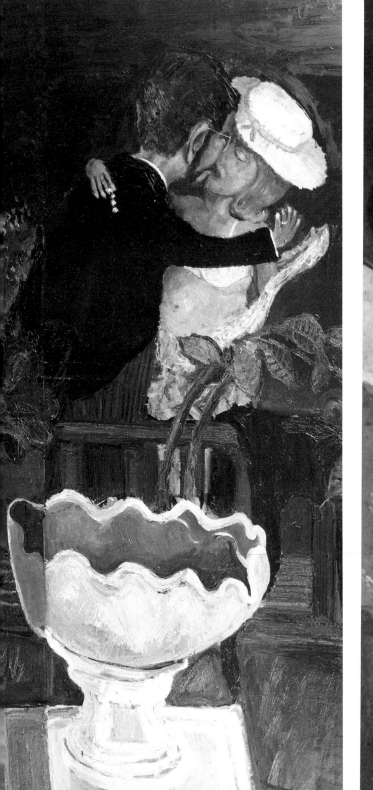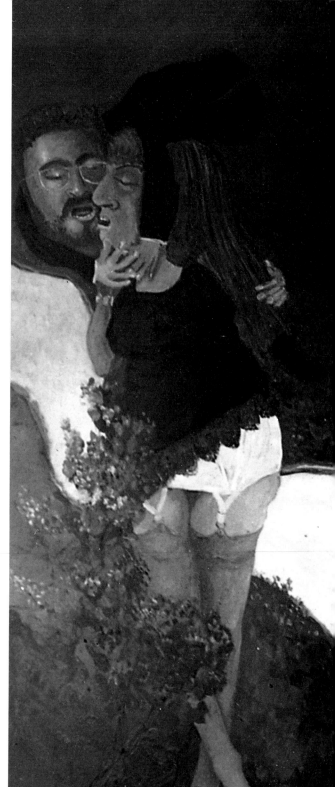

The Kiss I,
Lovemaking in Lissenden
Gardens,
Undressed Lady
and **Our Bedroom I.**

Delights of early married life.

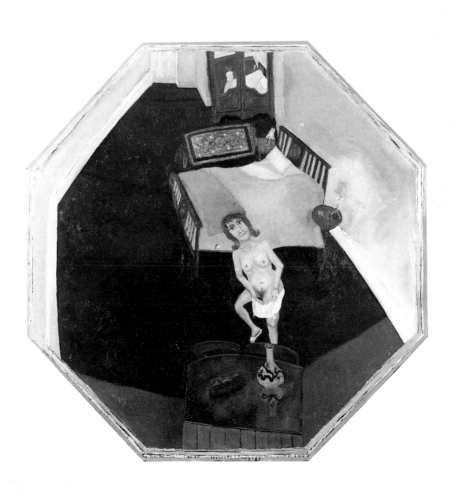

By 1964 the pictures were sometimes joined and cut up during their production, but only if the developing image demanded it. Both of these paintings were cut from the same board.

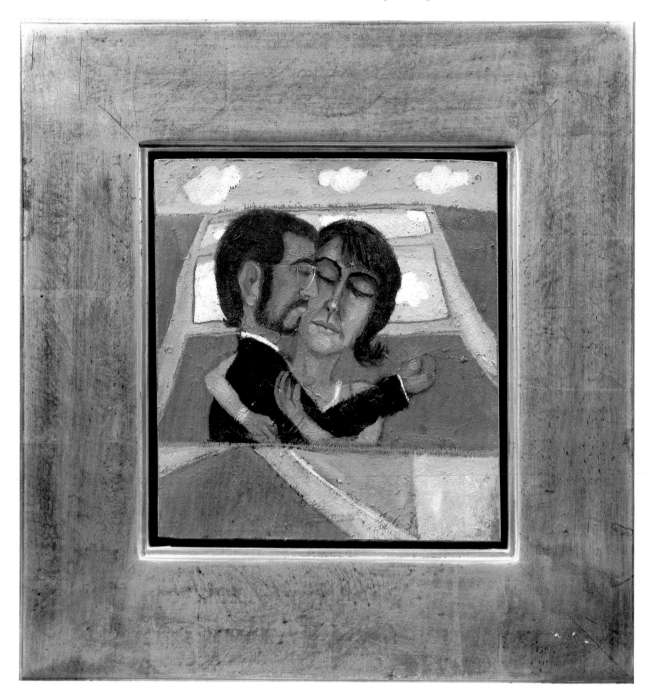

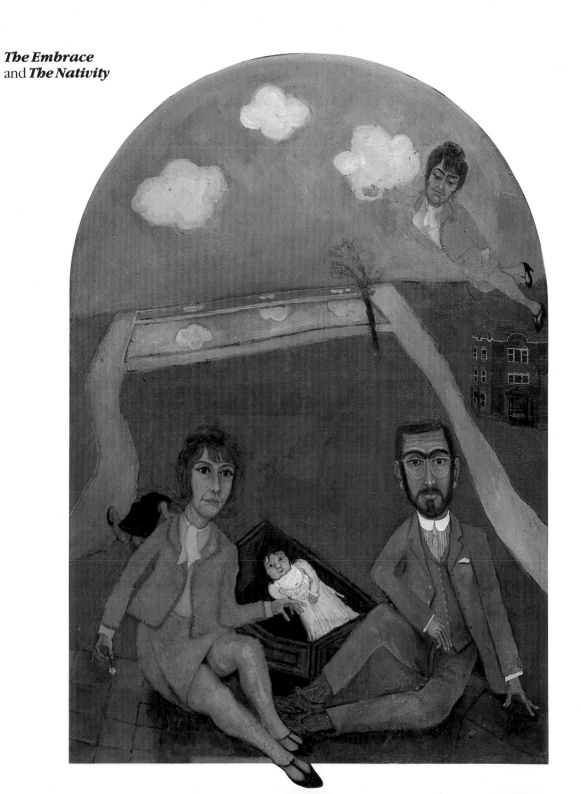

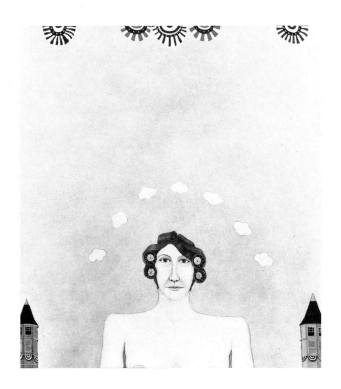

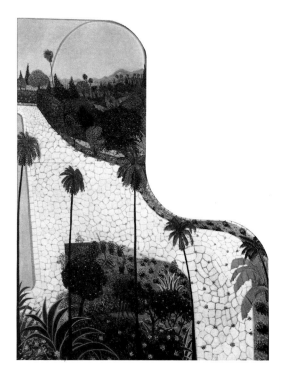

USA I

In 1967 I was awarded a Harkness Fellowship to paint in America. Our two-year stay had a profound effect on my work – the strong clear light liberated and strengthened my use of colour. Initially we settled on the East Coast in Leonia. I painted Mary in almost Byzantine glory, flanked by derelict buildings near the New Jersey Turnpike.

Death Valley

After a year overlooking Manhattan, we drove west.

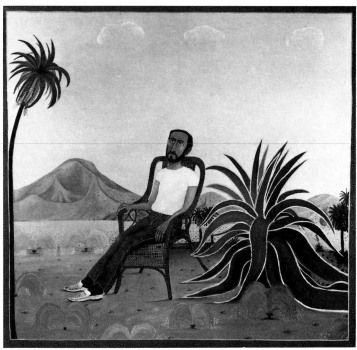

California II

Mary got into conversation with Kit and Tony Lewis at a campsite laundromat in Mesa Verde National Park. They invited us to stay with them in Altadena. Their pool was secluded.

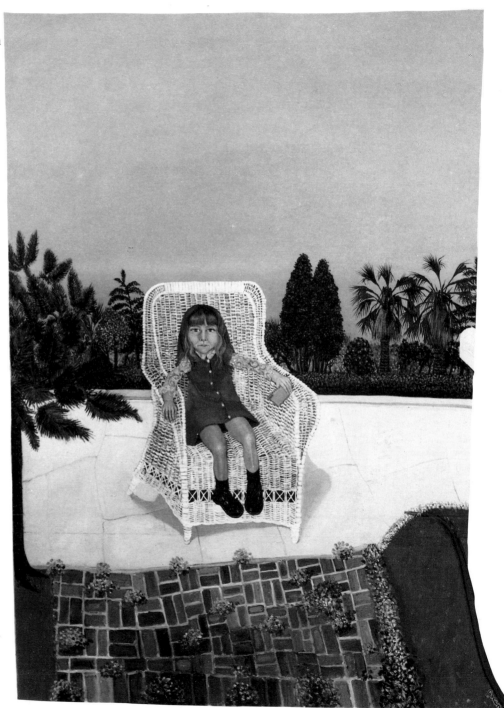

Miss Katharine Green: Altadena 91001, California

Katie was born with natural wisdom.

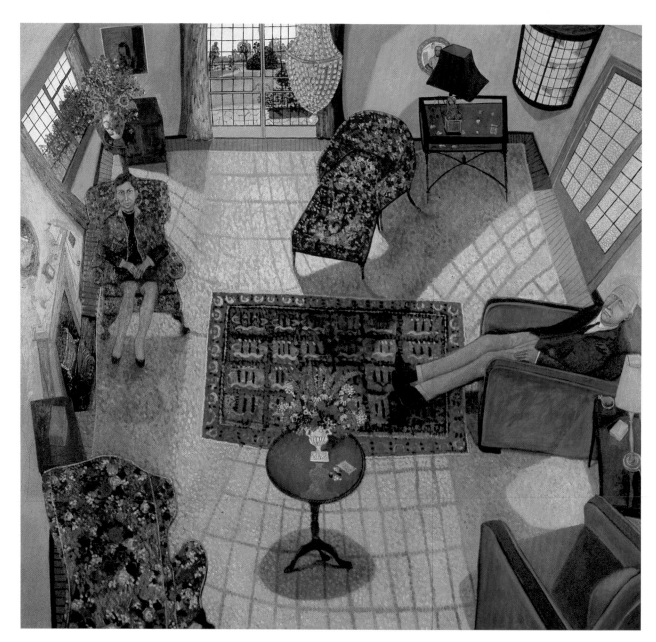

The United Kingdom

While in Altadena I painted my first very full room picture. Californian sunshine pours through the windows of my parents-in-law's home in Elstree. They have just received a letter from us.

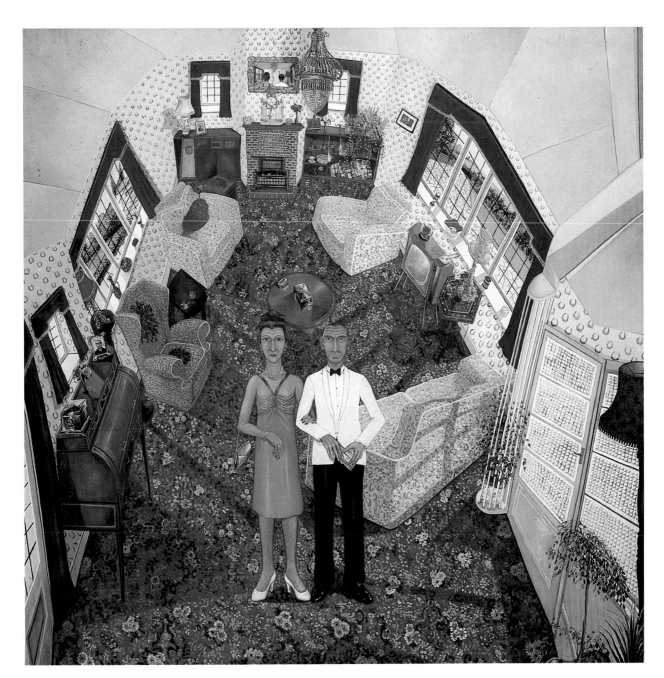

Mr & Mrs Stanley Joscelyne: The Second Marriage

My mother had remarried in 1953. During our stay in America she and
Stan moved into their dream house in Hendon Wood Lane NW7.

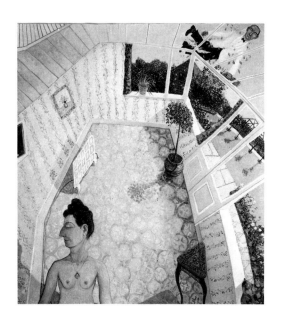

The Sun Parlour: A Memory

Stan died shortly after our return from America. He was a shy, dapper, kind man.

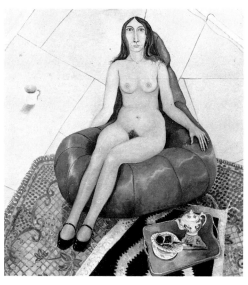

The Red Chair

Back again in Lissenden Mansions. We turned our bedroom into our living room and bought a new Italian chair. I was now confident enough to paint anything – even toast and Marmite.

Please Don't Die Darling Mary

Four months after our return from America, Mary had become pregnant. During the pregnancy Mary got an infected appendix. I was very, very worried.

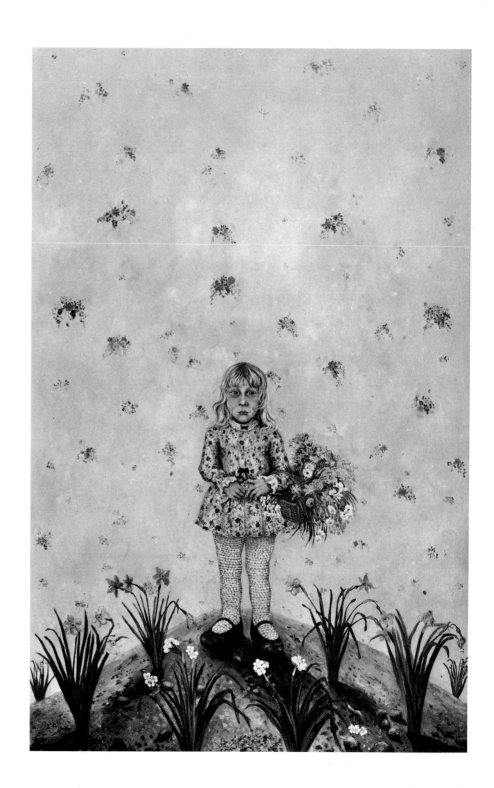

Lucy

Seeing Lucy being born
was an ecstatic
experience.

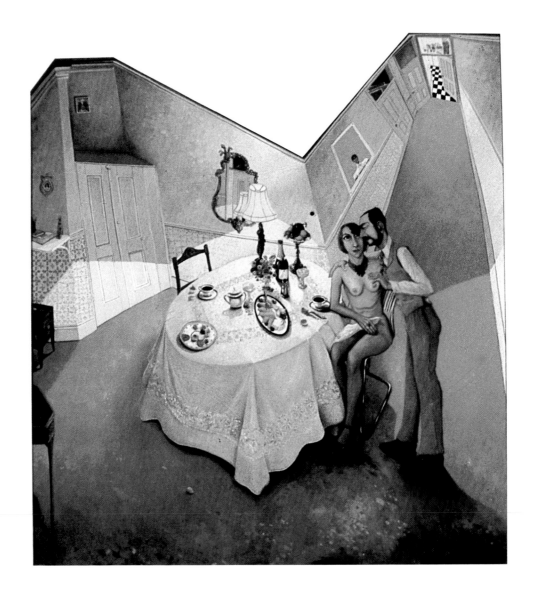

The Private Dinner

On the menu: smoked salmon, fruit,
petits fours, coffee, champagne for two.

The Kiss II >

Mr and Mrs Anthony Green in the
workroom at 17 Lissenden Mansions.

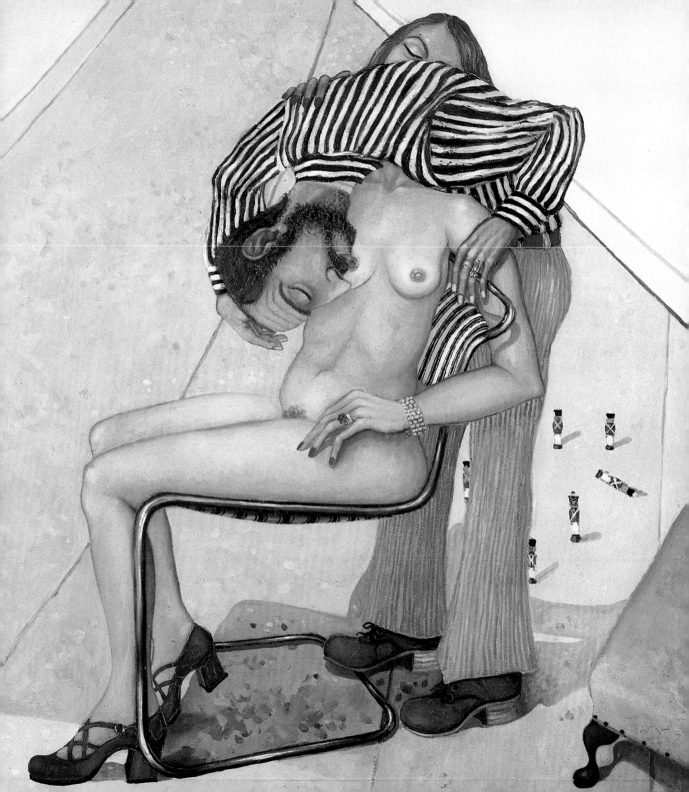

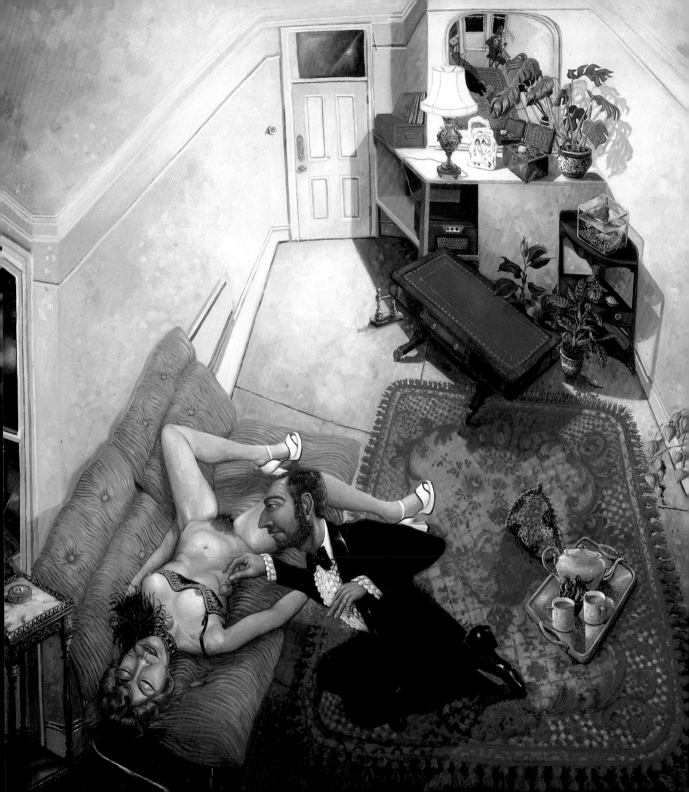

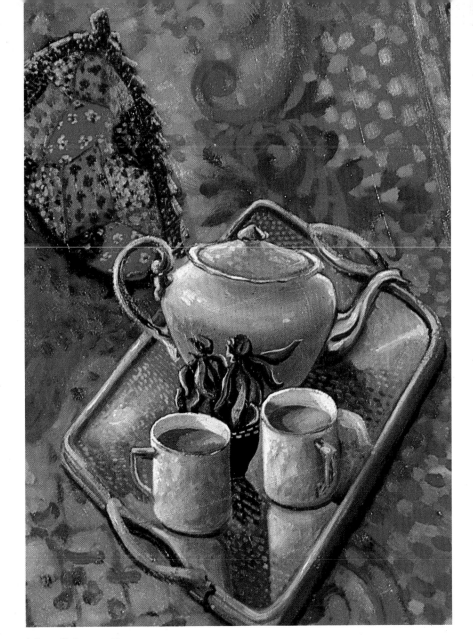

The Chinese Lantern

Mary's bra came in a plain brown envelope from a small mail-order company in Bradford which has since gone bust. It's part of a completely unreal world, and erotic bras at a fiver only work in the mind of the man who buys them. In the catalogue they look exciting, but in real life they are appalling. Flowers that have an inside are incredibly embarrassing. The dead orchids next to the tea cups are a reminder of our own mortality.

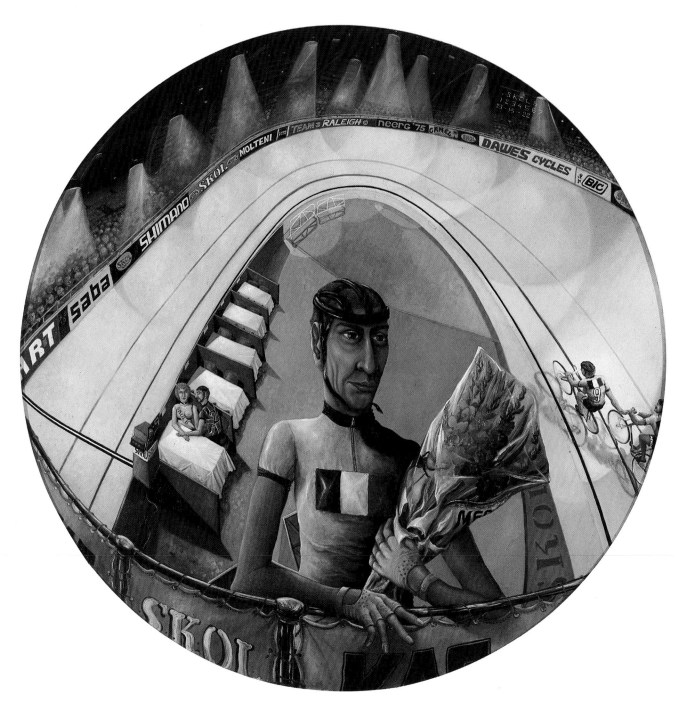

The Skol 6 Day

Ideas of glory appeal to me. As a boy I always wanted to win the Tour de France; I still do.

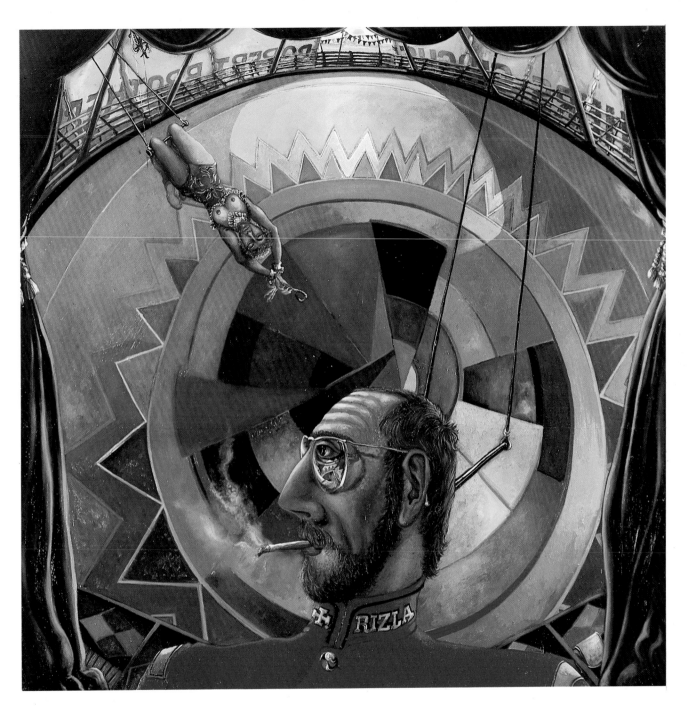

Rizla

Mary swinging on a trapeze at Robert Brothers Circus in Cambridge. I'm the attendant.

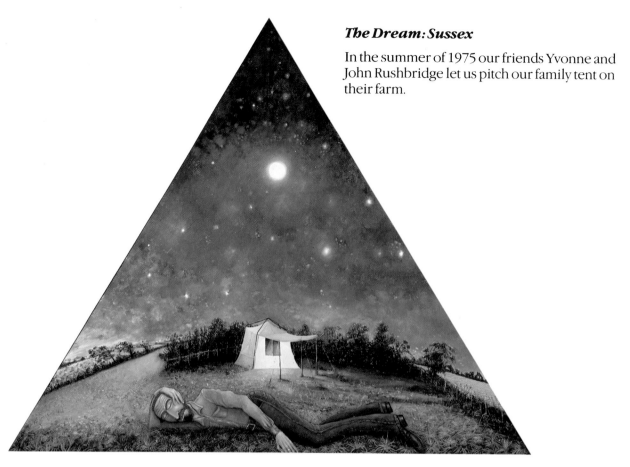

The Dream: Sussex

In the summer of 1975 our friends Yvonne and John Rushbridge let us pitch our family tent on their farm.

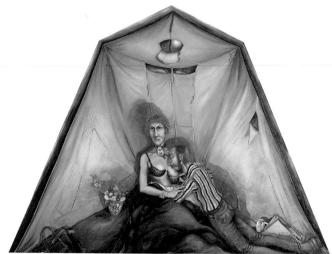

Our Tent: The Fourteenth Wedding Anniversary

Wedding anniversaries are very important to us, and since our eleventh I've tried to do a special picture every year. When Mary and I met as students, it was the hot passion of youth: the boy chasing and the girl running very slowly on the spot. But with maturity our love has bloomed and intensified. I won a plaster Red Indian at the fair in nearby Bracklesham Bay; he is in the cardboard box.

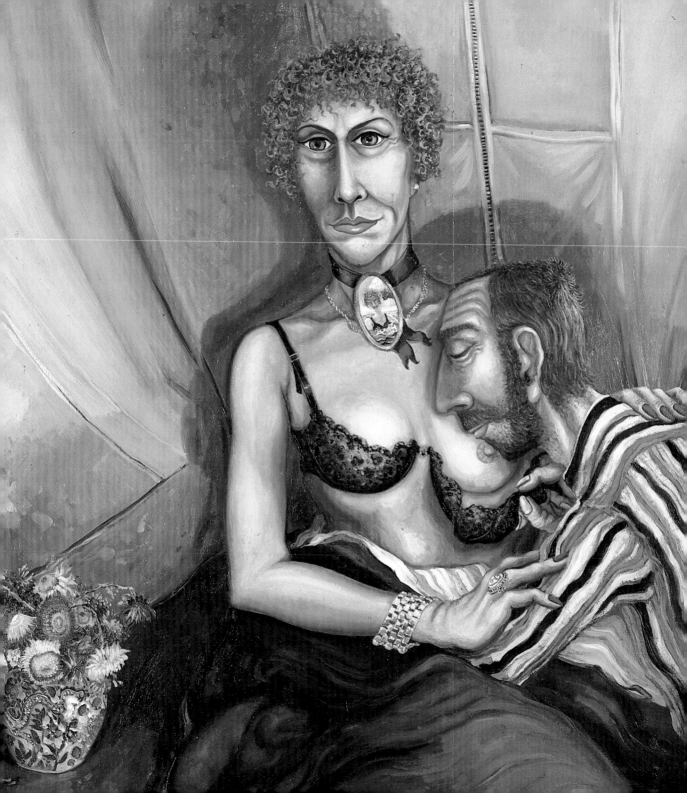

The Lissac Empire

Uncle Maurice, Aunt Yvonne's husband, is now a wealthy optician in Châteauroux. His son Michel works in the business. Father-son relationships are never easy; I remember my own.

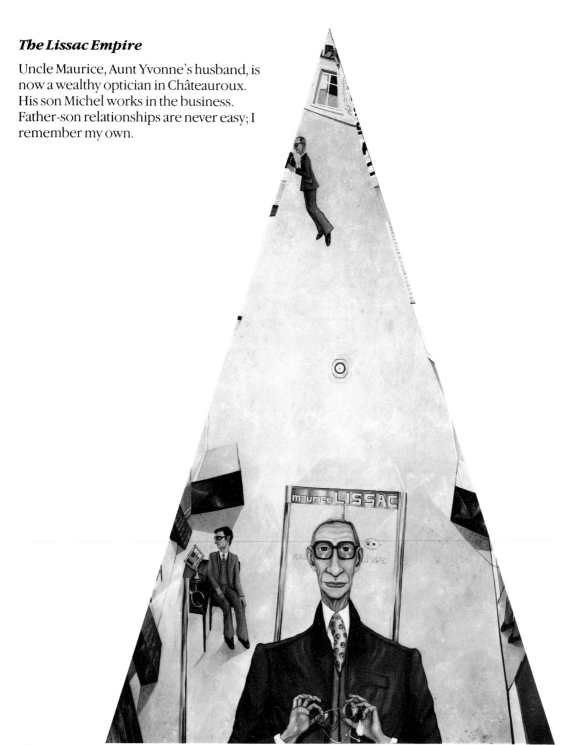

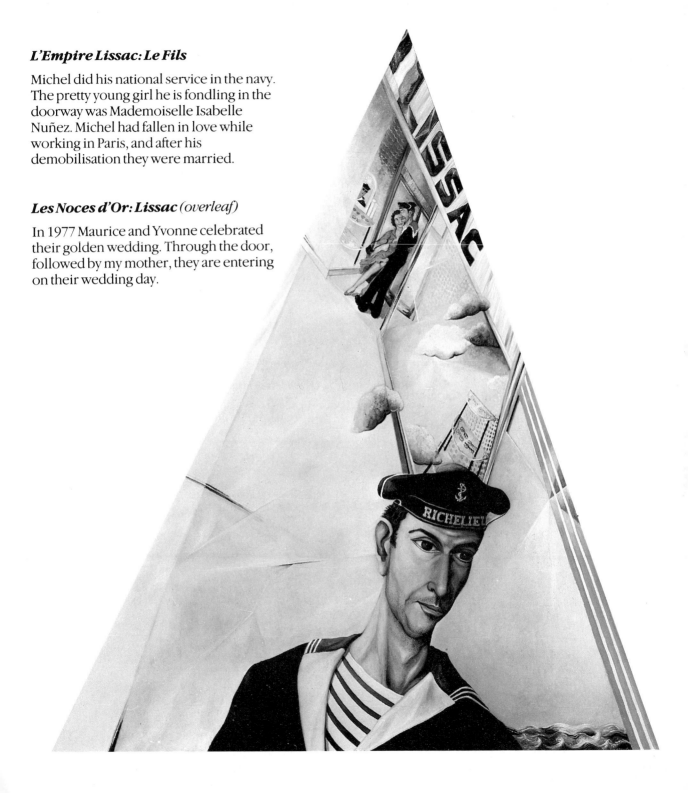

L'Empire Lissac: Le Fils

Michel did his national service in the navy.
The pretty young girl he is fondling in the
doorway was Mademoiselle Isabelle
Nuñez. Michel had fallen in love while
working in Paris, and after his
demobilisation they were married.

Les Noces d'Or: Lissac (overleaf)

In 1977 Maurice and Yvonne celebrated
their golden wedding. Through the door,
followed by my mother, they are entering
on their wedding day.

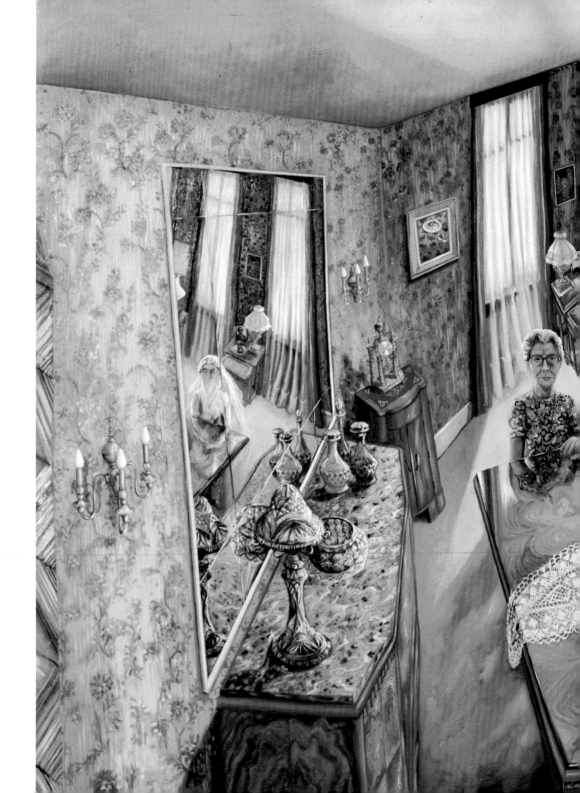

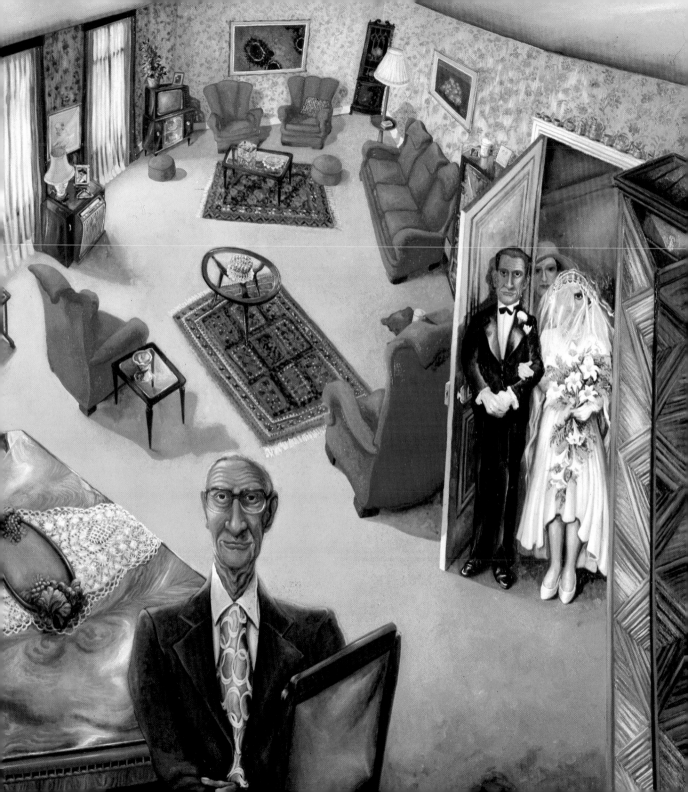

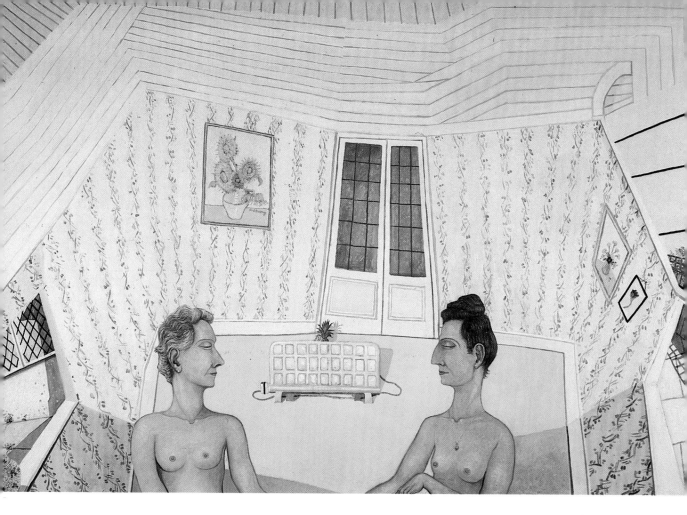

The Dupont Sisters

Yvonne and Madeleine, née Dupont, not in the
Louvre – but in Hendon Wood Lane. My mother
and aunt last quarrelled towards the end of La
Grande Guerre, over a hyacinth bulb. I love them
very much.

My Mother Alone in her Dining Room >

Madeleine was happily married for sixteen years
to my stepfather, Stanley Joscelyne. When he died
in 1969 she was broken-hearted.

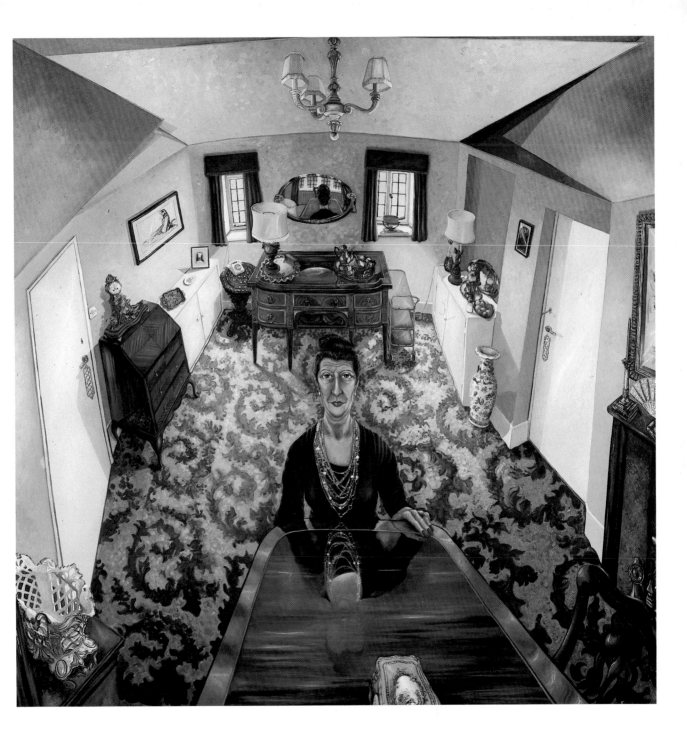

The Beautiful Dream:
Madeleine Joscelyne Alone, Bathing

A few years ago Mum redecorated
and chose a new bathroom suite.

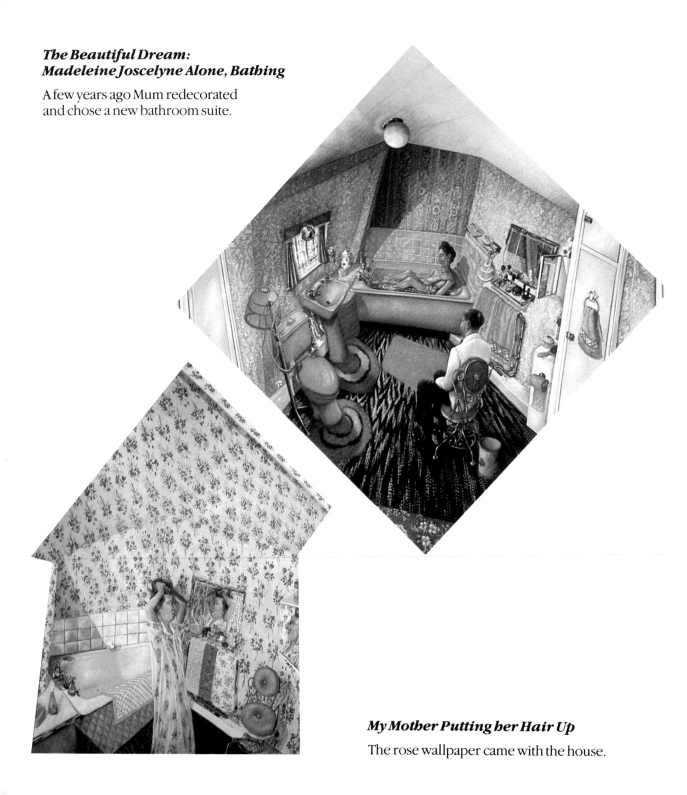

My Mother Putting her Hair Up

The rose wallpaper came with the house.

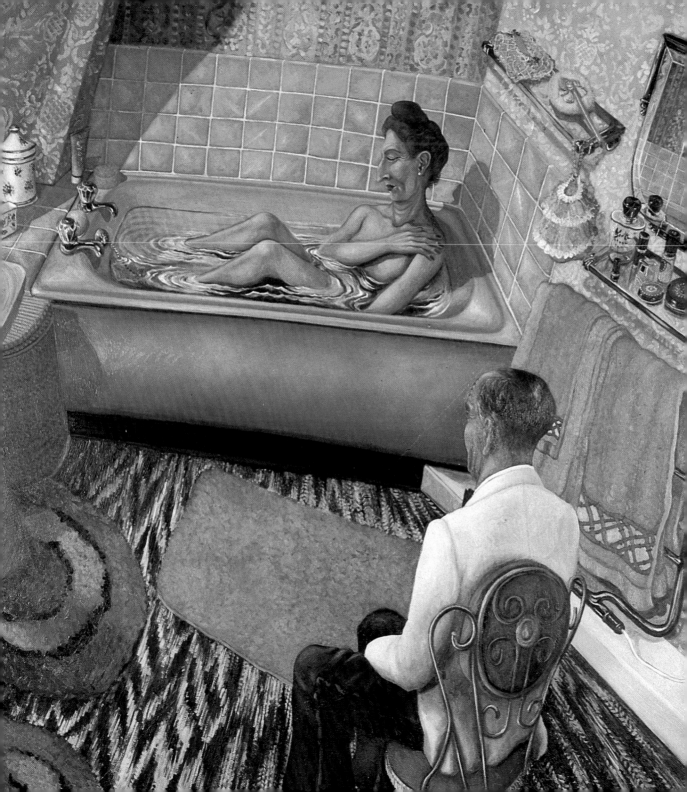

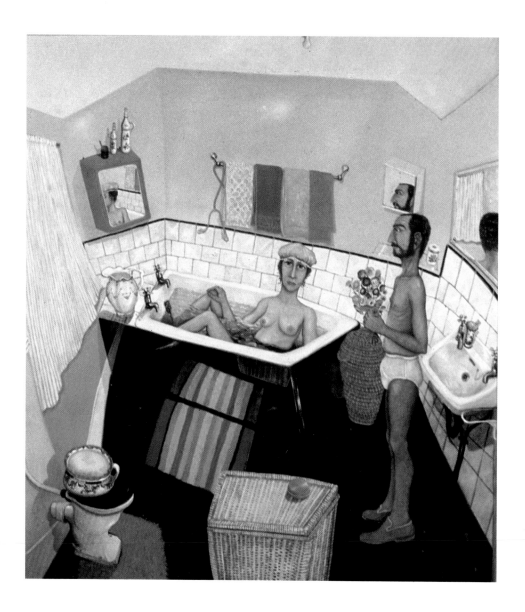

Our Bathroom

Bathrooms are very private places. People lock themselves in and do private things. Within marriage we share the same soap and lavatory seat, but not the face flannels.

The Bathroom at 29 >

When Camden Council did up Lissenden Mansions we were moved down the road for ten months.

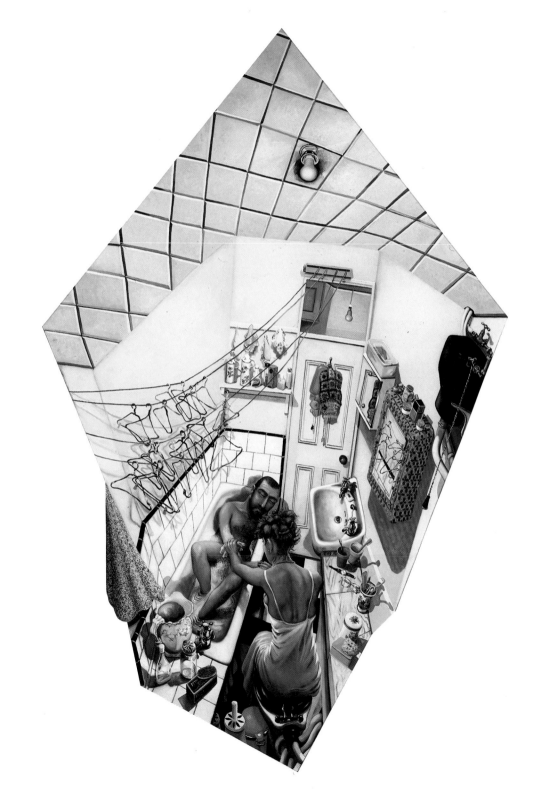

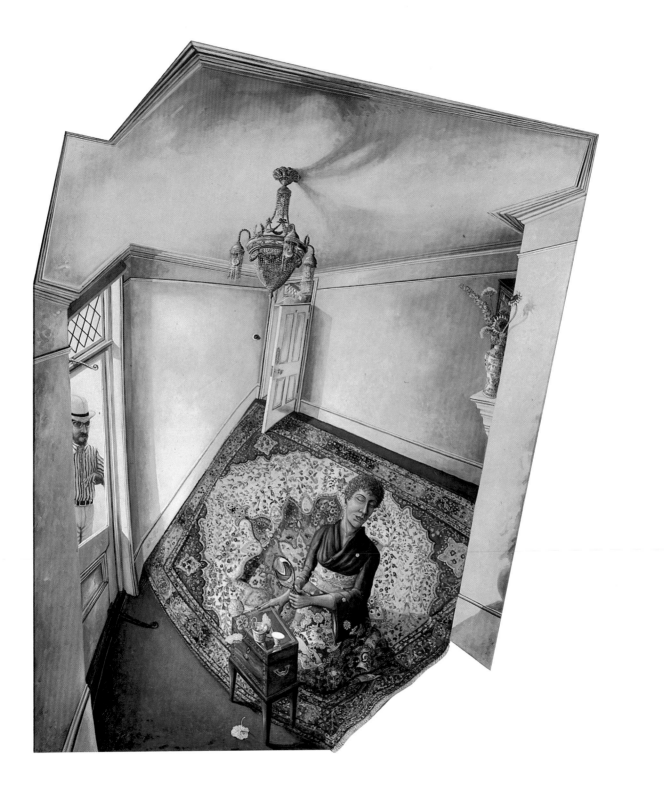

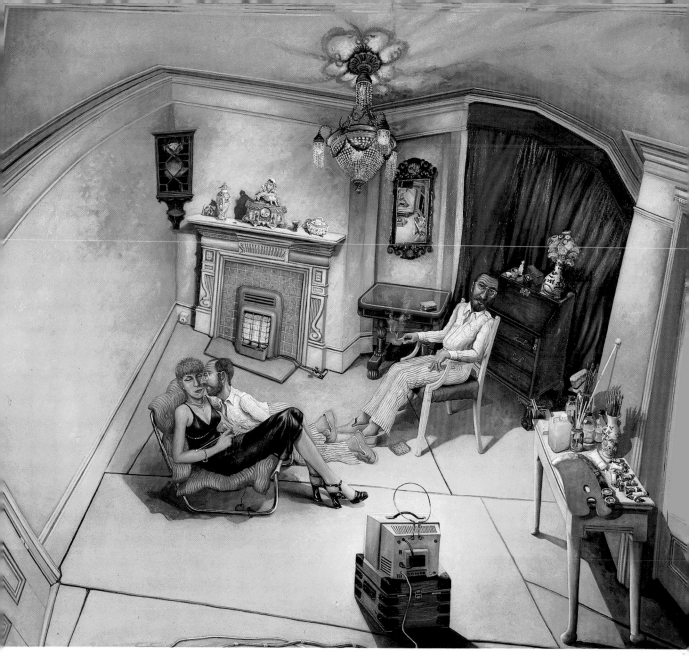

The 16th Wedding Anniversary: Our Carpet

Mary in a kimono, kneeling on a Persian carpet, surrounded by a Chinese vase, French reproduction chandelier, and English cigar box on legs. Anthony arrives from Tokyo with a pearl.

The Yellow Studio

The contentment of marriage. Mary is knitting, and I've been watching television. My clean palette, sable brushes and oilpaints are neatly arranged for the morning.

61

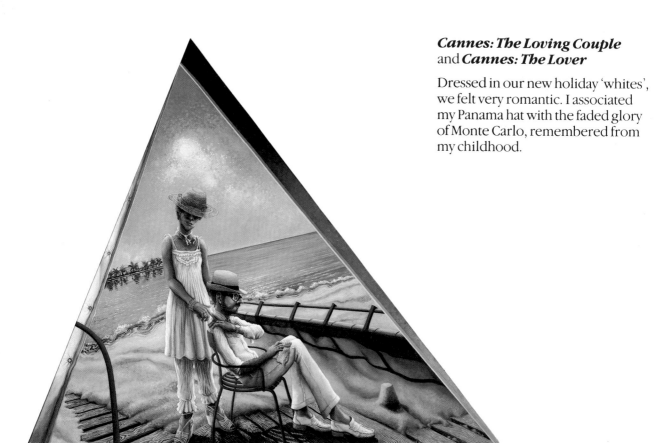

Cannes: The Loving Couple and Cannes: The Lover

Dressed in our new holiday 'whites', we felt very romantic. I associated my Panama hat with the faded glory of Monte Carlo, remembered from my childhood.

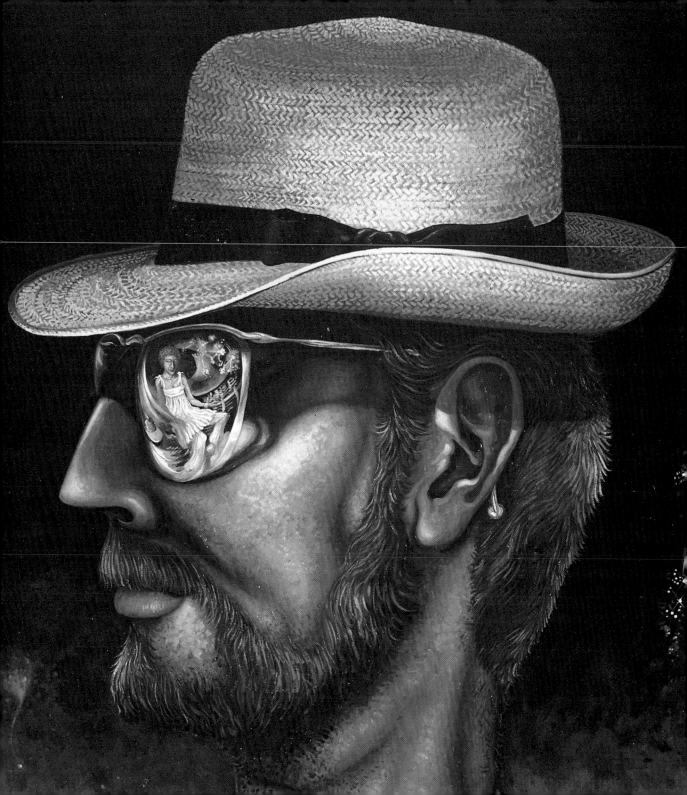

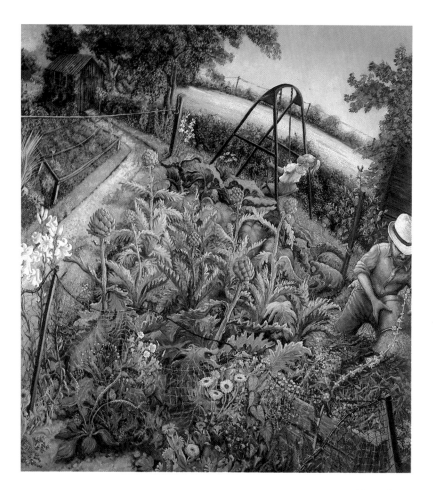

Lucy's Artichoke Patch

Lucy is a sharp and humorous schoolgirl; one day she will amaze us. She complains there is too much art in our family. In spite of this, next time I may paint her with a calculator and her violin.

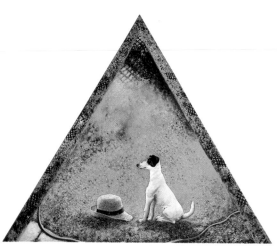

Her Master's Hat

Rosie.

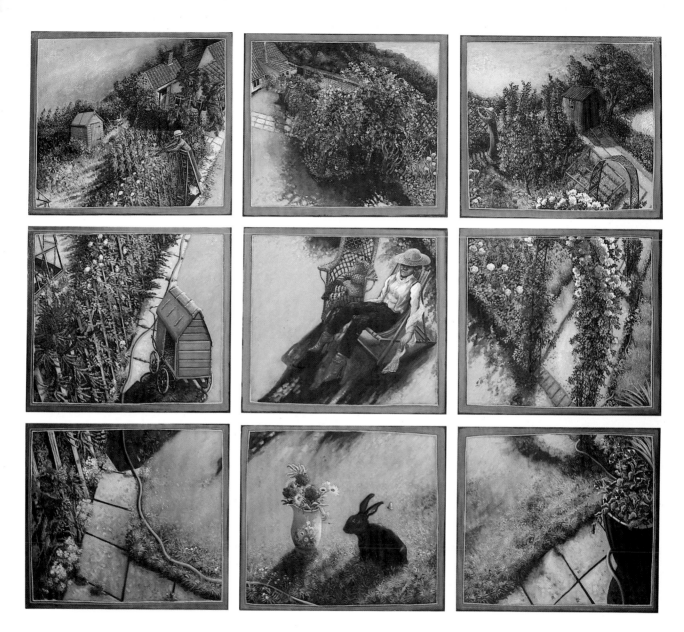

Pictures of our Garden

Katie growing into a beautiful young lady, wearing her new outfit complete with very high heels and golden waistcoat. She might be a poet and is going to art school in London. One day she may even paint me.

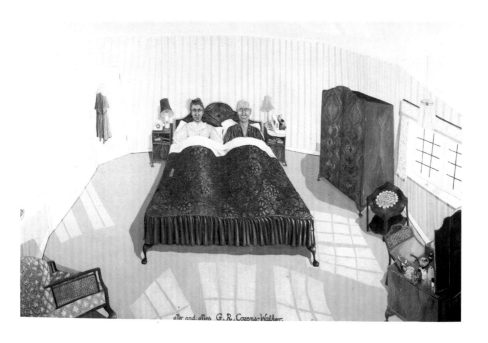

Mr & Mrs G. R. Cozens-Walker

Mary's parents in the comfort of their double bed at Elstree with their Teasmade. Bob and Margaret have been married for over forty years.

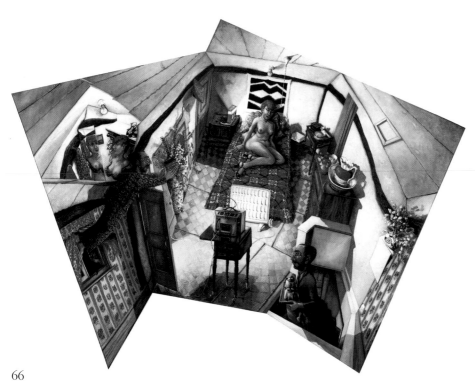

The Seventeenth Wedding Anniversary: Our Bedroom at Mole End

Coming up the stairs at Little Eversden, our country cottage, with the teapot and kettle for our Teasmade while Mary is undressing. The lover flies through the window bearing opium for his naked bride.

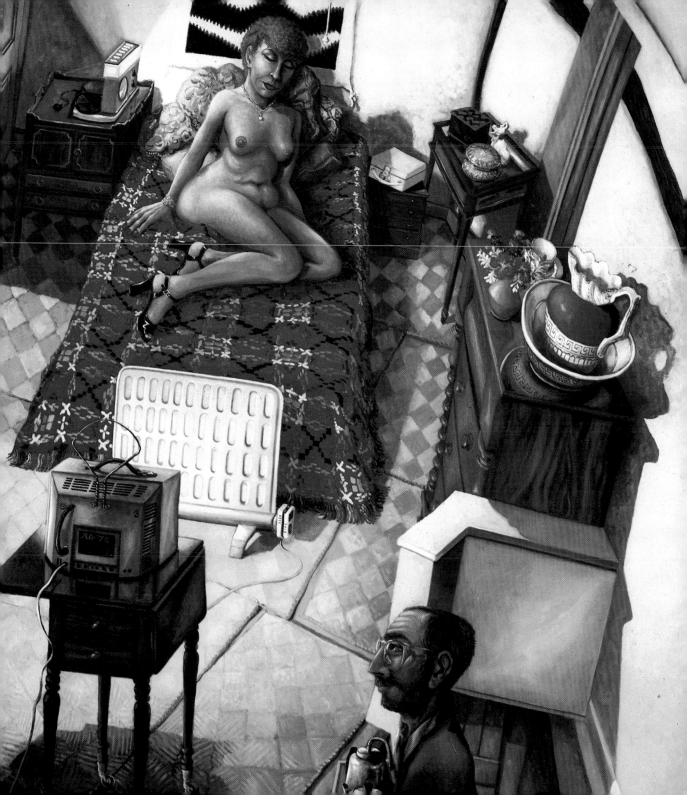

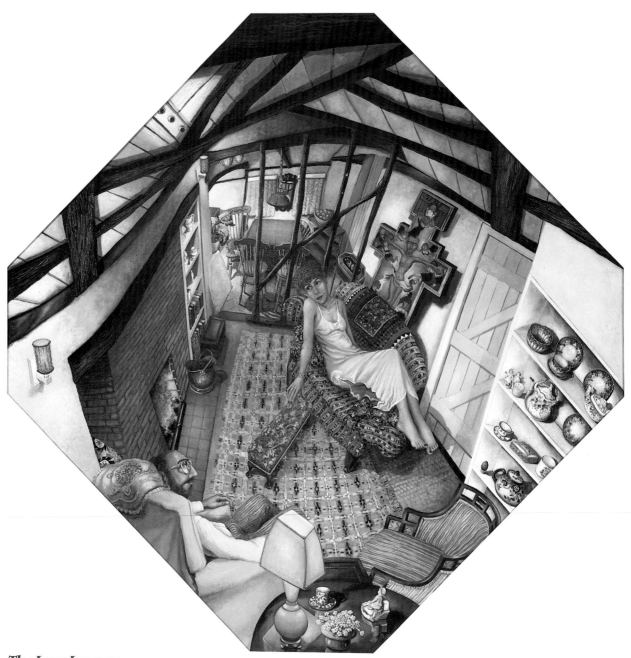

The Love Lounge

I bought the nightie in New York. Three weeks
later I painted Mary wearing it.

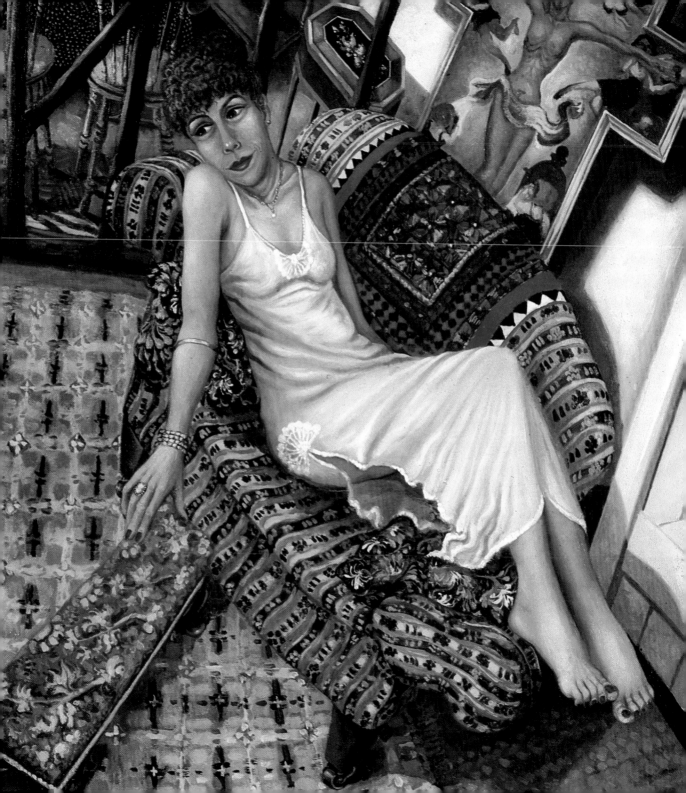

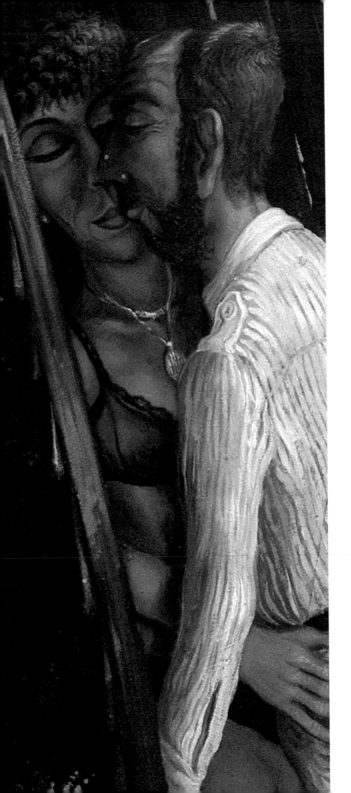

The Enchanted Garden: Twentieth Wedding Anniversary

For our twentieth anniversary I wanted to do a grand composition celebrating sacred and profane love. During the summer, while I was gardening, the late afternoon sun slanted through the spiralling bonfire smoke. Into this earthly paradise, the loving husband swoops down to gently crown his wife with a daisy coronet. Nearby I'm ardently cuddling Mary. Katie's rabbit seems more concerned by the smoke.

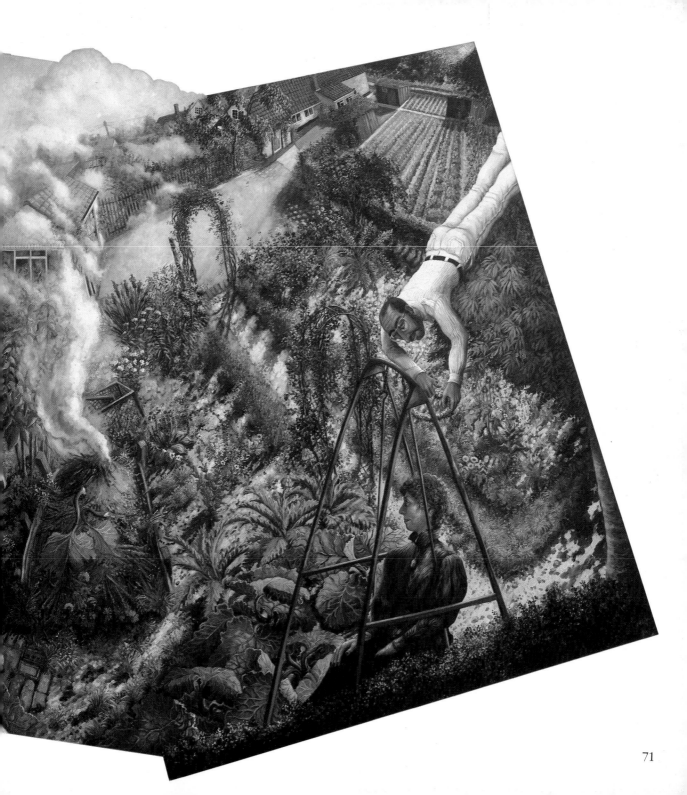

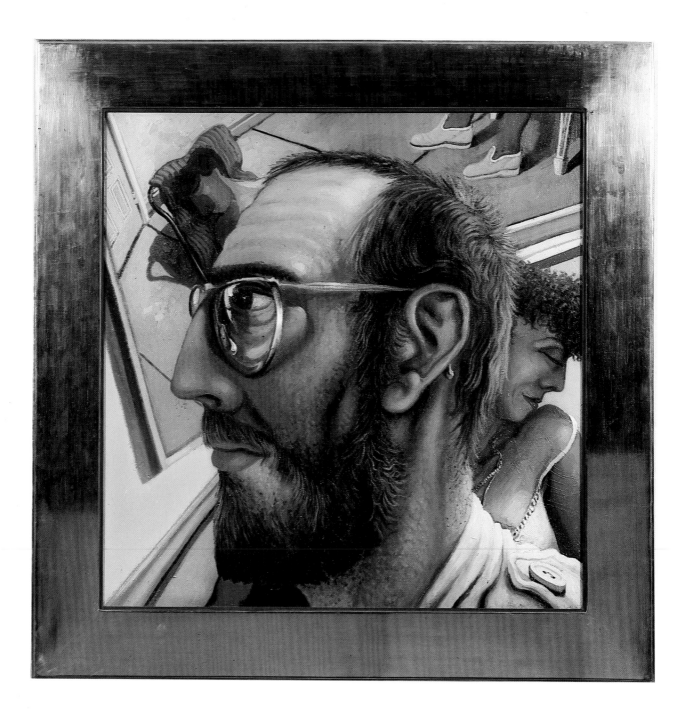

Acknowledgements

If Martin Bailey had not phoned me, and suggested that we meet, there might still have been a Green book – but it would have been a more conventional and less exciting work. Together we decided to assemble a chronological account of my family narrative which will hopefully be of interest beyond the confines of the art world. The fact that Martin Bailey is not an established art critic (but a reporter for *The Observer*) appealed to me. Our collaboration has been happy and stimulating, and I thank him for his patience and editorial skill.

My thanks must also go to Alex Gregory-Hood of the Juda Rowan Gallery for his constant encouragement, help and advice over the period of twenty years that these pictures have been painted. Every professional artist needs a good dealer – I've got the best.

Ringing, writing and chasing around the world for the illustrations was an endless and sometimes frustrating task. Francie Prichett accomplished this with great efficiency and cheerful calm. The Juda Rowan, Brusberg, Nishimura, Staempfli and Everard Reed galleries have all given enthusiastic support to this venture.

Simon Kingston gave his support at the very beginning when the idea was small and fragile.

When I could not remember family dates and places, Madeleine Joscelyne and Yvonne Lissac came to my rescue. My thanks to both to them.

Last, but by no means least, my special thanks go to Mary. She is my inspiration. Without her there would have been no pictures – and no book.

< ***September 40th***

For my fortieth birthday, I made a celebration icon, framed in the best quality gold leaf. I'm greying slightly at the temples.

List of pictures and locations

All are oil on board except where otherwise stated. Sizes given in inches.

Page	Title	Size	Date	Collection
Frontis-piece	The Loving Room (detail)	70×89	1979	Galerie Brusberg, Germany
7	Minnie Mouse and Donald Duck (Pencil and crayon on paper)	8½×11½	1948	Artist's Collection
8	Copy of Van Gogh's Sunflowers	36×28¼	1957	Private collection, U.K.
8	La Mariée	49×37½	1961	Artist's Collection
9	Black Crucifix	72×48	1965	Artist's Collection
11	No 2 Brunswick Mews, 1939	63×96	1972	Harold Reed, NY
12	The Accident	68×68	1980	Juda Rowan Gallery, London
13	Victory in Europe: The Greens 1945	68×72	1981	Arts Council of Great Britain
14	Pâques 1948: Le Raincy	81×109	1981	Setagaya-ku Museum, Tokyo
14-15	Christmas Mirror 1947	78×112	1982	British Council
16	Mme Madeleine Green et son fils: Le Raincy, Seine-et-Oise 1948	78×78	1981	Juda Rowan Gallery, London
17	1980 Mending the clock: A Memory 1946	72×73	1980	Setagaya-ku Museum, Tokyo
18	'La France' au 14 Lissenden Mansions 1944?-45	80×48	1980	Nishimura Gallery, Tokyo
19	Casimir Dupont	86×86	1980	Tate Gallery, London
20	The Mirror 1952-56	80×72	1981	Juda Rowan Gallery, London
21	Regal Rubber Company 1954	72×48	1980	Private Collection, NY
22	L'Heure du Thé: Argenton sur Creuse, Département de l'Indre	78×87	1980	Chantrey Bequest, Tate Gallery, London
23	Châteauroux: Les Secrets du Confessional 1957	80½×94	1982	Juda Rowan Gallery, London
24	Femme	49×35	1961	Artist's Collection, Little Eversden
24	La Mariée	49×37½	1961	Artist's Collection
24-25	La Chambre Bleu	69×86	1975	Zimmerman Collection, USA
26-27	Hall of Mirrors 1958	90×82	1977	Stanley Westreich, Alexandria, Virginia, USA

28	My Lovely Bride	83×75	1978	Nishimura Gallery, Tokyo
29	The Wedding	66×108	1962/3	Calouste Gulbenkian Foundation, Lisbon
29	The Ravisher (Gouache on paper w/second-hand frame)	15⅞×14¾ (framed)	1962?63?	Artist's Collection
30	My late father's sister: Win	62 diam	1978	Artist's Collection
30	The Enigma	60 diam	1977	Private Collection, Japan
31	Young Man with a Grenadier	78½×67½	1983	Juda Rowan Gallery, London
32	The Kiss I	48×36	1963/64	Barry Skrine, London
32	Lovemaking in Lissenden Gardens	triptych: overall: 84×108	1964	Scunthorpe Borough Museum
33	Undressed Lady	49×36	1961	Peter Cochrane, England
33	Our Bedroom I	48×48	1966	Thomas Lenk, Germany
34	The Embrace (Oil on board & gold leaf frame)	7×7½ (ex. frame)	1966	Alistair Horne, London
35	The Nativity	52×36	1966	Mr & Mrs David Gibson, London
36	California II	81×60	1968/69	Juda Rowan Gallery, London
36	Death Valley	44×48	1968	Capt. James West, England
36	USA I (Oil on canvas)	48×44	1968	Private Collection, London
37	Miss Katharine Green: Altadena 91001, California	70½×53	1968	Frans Hals Museum, Haarlem
38	The United Kingdom	68×72	1969	Edward L. Gardner, USA
39	Mr & Mrs Stanley Joscelyne: The Second Marriage	84×84	1972	Ulster Museum, Belfast
40	The Sun Parlour: A Memory	61×55	1971	Dr Martin L. Robinson, Canada
40	The Red Chair	85×83	1970	Galerie Brusberg, Germany
40	Please Don't Die Darling Mary	60×96	1969/70	J. A. Cloughley, NY
41	Lucy	72×48	1973	Ned L. Pines, Paris
42	The Kiss II	69×66	1972	Private Collection, London
43	The Private Dinner	72×66	1972	Dr Martin L. Robinson, Canada
44-45	The Chinese Lantern	72×81	1974	Marc Moyens, Washington, DC
46	The Skol 6-day	72 diam	1975	Tochigi Prefectural Museum of Fine Arts, Japan
47	Rizla	60×60	1977	Nishimura Gallery, Tokyo
48	The Dream: Sussex	78×96	1973	Belle Shenkman, London

48-49	Our Tent: The Fourteenth Wedding Anniversary	72×96	1975	Rochdale Art Gallery
50	The Lissac Empire	111×75	1973	Juda Rowan Gallery, London
51	L'Empire Lissac: Le Fils	84×72	1975	Ned L. Pines, USA
52-53	Les Noces d'Or: Lissac	60×96	1976	Ned L. Pines, USA
54	The Dupont Sisters	48×72	1972	J. Lancaster, England
55	My Mother Alone in her Dining Room	72×72	1976	Sainsbury Centre for Visual Art, Norwich
56	My Mother Putting her Hair Up	68×54	1974	Ikeda Museum of 20th Century Art, Japan
56-57	The Beautiful Dream: Madeleine Joscelyne Alone, Bathing	110×110	1978	Everard Reed Gallery, South Africa
58	Our Bathroom	61×55	1973	J. Bell, Kansas City
59	The Bathroom at 29	85×55	1979	Sainsbury Centre for Visual Art, Norwich
60	The Sixteenth Wedding Anniversary: Our Carpet	94×78	1977	Debenhams, London
61	The Yellow Studio	78×90	1979	Galerie Brusberg, Germany
62	Cannes: The Loving Couple	80×96	1977/78	Douglas Woolf, London
62-63	Cannes: The Lover	54×108	1977	Capt James West, England
64	Her Master's Hat	51×63	1980	Galerie Brusberg, Germany
64	Lucy's Artichoke Patch	63×57	1978	Edward L. Gardner, USA
65	Pictures of Our Garden	87×99	1979	Everard Reed Gallery, South Africa
66	Mr and Mrs G. R. Cozens-Walker	60×90	1972	Harold Reed, NY
66-67	The Seventeenth Wedding Anniversary: Bedroom at Mole End	85×115	1978	Galerie Brusberg, Germany
68-69	The Love Lounge	74½×74½	1979	Private Collection, Japan
70-71	The Enchanted Garden: Twentieth Wedding Anniversary	83×107	1981	Jared Drescher, USA
72	September 40th (Oil on canvas)	39½×39½ (framed)	1979	Nishimura Gallery, Japan
77	The Peaceful Kingdom	96×91	1976	Galerie Brusberg, Germany

Photographic Acknowledgements

Photographs by John Webb, with the exception of those on pages 14, 17 (Setagaya-ku Museum); 18, 28, 47, 72 (Nishimura Gallery); 29 (Gulbenkian Foundation); 37 (Frans Hals Museum); frontispiece, 40 top, 61, 64, 66-67, 77 (Galerie Brusberg); 46 (Tochigi Prefectural Museum of Fine Arts); 56 (Ikeda Museum of 20th Century Art); 56-57, 65 (Everard Reed Gallery).

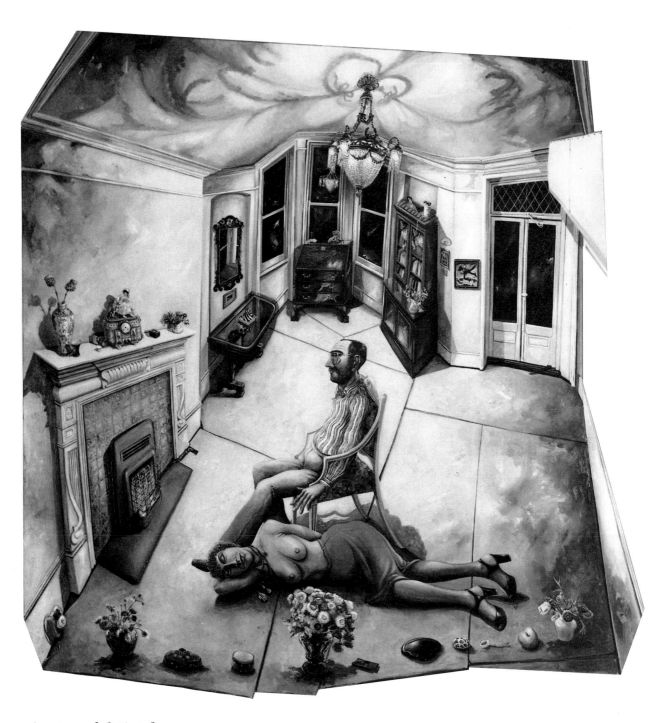

The Peaceful Kingdom

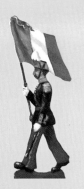

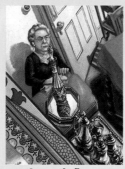

Jeanne Le Breton
(1882–1963)

=

Casimir Dupont
(1880–1961)

Maurice Lissac
(1907–)

=

Yvonne
(1907–)

m(i) (1933–1953)
m(ii) (1953–1969)

(mii) =

Marie-Madeleine (mi)
(1910–)

Michel
(1932–)

=

Isabelle Nuñez
(1933–)

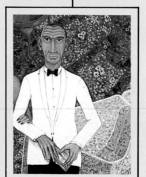

Stanley Joscelyne
(1893–1969)

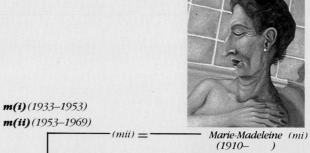

Anthony
(1939–)

Christine
(1959–)

Marc
(1964–)

Katharine Charlotte
(1965–)